THE
FLASH STICK

CREATIVE OFF-CAMERA LIGHTING SOLUTIONS FOR THE SOLO PHOTOGRAPHER

ROD AND ROBIN DEUTSCHMANN

AMHERST MEDIA, INC. ■ BUFFALO, NY

ACKNOWLEDGMENTS—We would like to thank everyone who helped in the making of this book—from our students who provided the inspiration, to our children who offered their time and heartfelt dedication. We consider ourselves blessed for having so many of both.

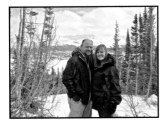

ABOUT THE AUTHORS—Rod and Robin Deutschmann have been teaching people to be artists with their cameras for years. Taking a practical approach to modern photography, the duo strips the nonsense from the facts and the hype from the truth. They believe that creativity lies in the artist's soul and not his camera bag. Touting the advantages of manual control, they offer a fresh view of photography that rebels against the norm. Their innovative approach and down-to-earth style have garnered them a loyal following of Southern California photographers. To learn more, go to www.facebook.com/IFLCSanDiego.com.

Published by:
Amherst Media, Inc.
P.O. Box 586
Buffalo, N.Y. 14226
Fax: 716-874-4508
www.AmherstMedia.com

Publisher: Craig Alesse
Senior Editor/Production Manager: Michelle Perkins
Assistant Editor: Barbara A. Lynch-Johnt
Editorial Assistance from: Carey A. Miller, Sally Jarzab, John S. Loder
Business Manager: Adam Richards
Marketing, Sales, and Promotion Manager: Kate Neaverth
Warehouse and Fulfillment Manager: Roger Singo

ISBN-13: 978-1-60895-532-9
Library of Congress Control Number: 2012936512
Printed in The United States of America.
10 9 8 7 6 5 4 3 2 1

Check out Amherst Media's blogs at: http://portrait-photographer.blogspot.com/
http://weddingphotographer-amherstmedia.blogspot.com/

TABLE OF CONTENTS

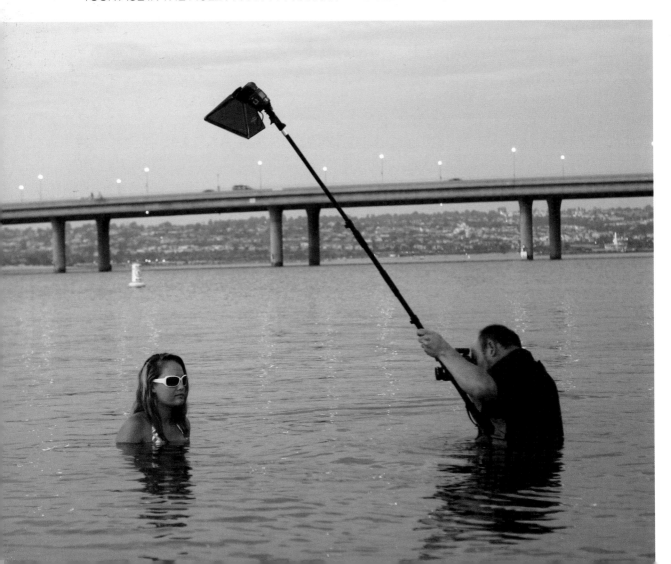

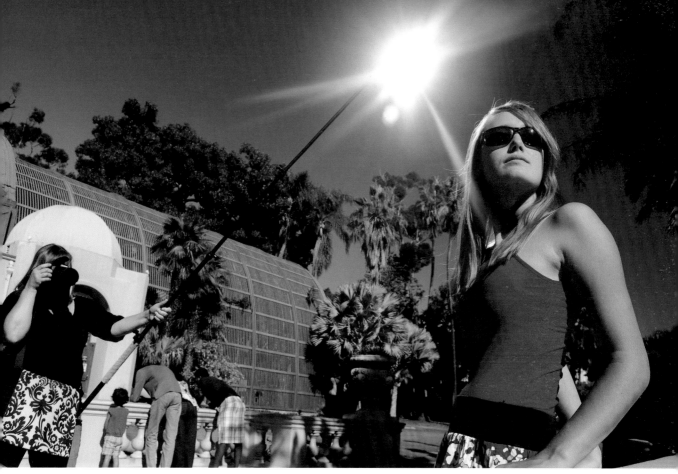

INTRODUCTION

The tools of an artist have always been fluid; items are often repurposed as ideas expand. What seems odd one day will be commonplace the next. Photography is no different. Cameras change, approaches adjust, and our tools evolve; we grow as artists, and our equipment follows suit.

The flash stick is one such tool. It offers a wealth of new and exciting possibilities for the unassisted, off-camera flash photographer. It is simply the next step in the evolution of digital photography. We're very proud and honored to offer this explanation of its use.

Great flash photography (whether using a stick or not) requires both vision and confidence. Confidence is gained through experience; vision is built by desire. These are the two qualities we want

BELOW—This image in no way resembles reality (how things appeared). The photographer saw the picture in his head, then dialed in the contrast, saturation, and white balance settings that would produce the "feel" that you see. Next, he chose an aperture setting (f/20) that allowed for substantial depth of field. His shutter speed selection ($^1/_{200}$ second) created the mood, producing a very dark theater in which he could add light to other pieces of his story—particularly the cactus. Since an on-camera flash would have produced shadows the eye is not used to, an off-camera "sticked" approach was chosen. The rest was simple: the flash was attached to the end of a flash stick, and the photographer pushed the light out and over the cactus. You'll also notice that the flash was positioned just to the left of the cactus. This was done to create even more intriguing shadows.

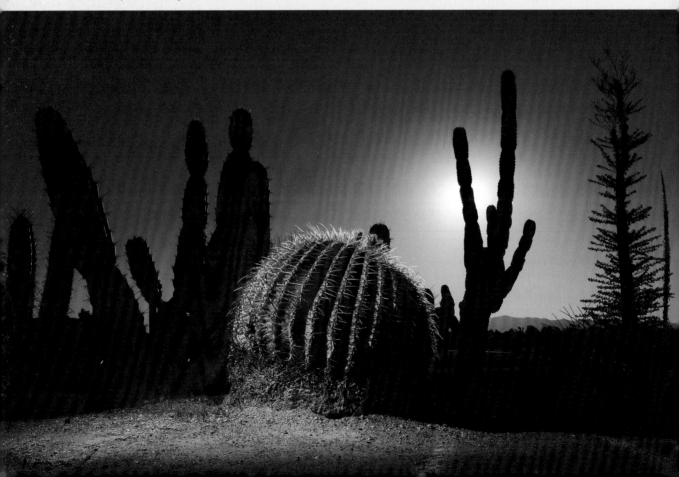

TOP—This is how the scene appeared to the naked eye. As you can see, creative flash photography has very little to do with how something *really* looks. It's more about how something *could* look if you took advantage of both the ambient light in front of you and of the light you can create with the flash.

BOTTOM—Here you can see how the flash stick was placed. Take note that there was no need to modify the flash in any fashion (no softbox, umbrella, or snoot).

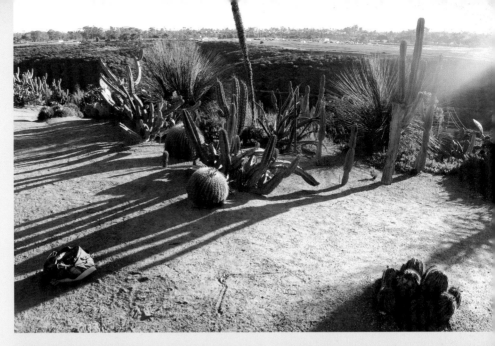

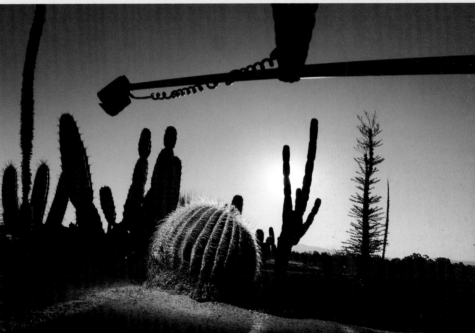

IT STARTS WITH A VISION

It starts with a vision—a solid idea from an artistic soul. "Simply know what you're trying to say and make it happen," we tell our students. "Think before you shoot. Visualize an outcome, then just use what you've got to make it happen. If you don't *have* what you need, then *make* it."

to instill through this book. We've loaded it with tons of before-and-after images, technique walk-throughs, and even several insightful exercises. We want this to be a time of exploration and a time of triumph for you. Sure, much of what you'll read and take from this book will be challenging, but anything worth having is worth a challenge. Nothing in life is free—especially skill and pride.

Getting Started

What you'll find here will hopefully lie beyond your wildest imagination. We'll show you how to create a message so unique that no one else will ever be able to duplicate it. We'll show you how to speak with your camera and flash, and we'll prove to you why pushing it as far from the camera as possible is not only a good thing, but it's one of the most powerful options an artist has when working solo. We'll start small with the basics and work our way up to the amazing and outlandish. We'll ask you to push your equipment and your vision farther than ever before with the sole purpose of giving the artist inside you even more flexibility. We want you to grow as an artist, to push society's buttons, to create rather than take. We want this book to help inspire.

This is hardly a "flash photography made easy" book or a simple collection of tricks. It is as much a book on our philosophy of shooting and creating in manual mode as it is an instructional guide to

using a flash off-camera attached to the end of a "stick." Those who have yet to master the manual control of their equipment may find the exercises and techniques in this book to be a bit challenging. To this end, we've included as many insights as we

True Artistry

The creative photographer is able to move far beyond "documenting" the world in pictures. He can envision and produce images that in no way resemble the world as it appears to the human eye. He is an artist, and his gear and the world around him are the tools of his trade. He pushes himself and his vision beyond what average people can (or are willing to) see, and his images show it—they are unique, bold, brazen, and amazing.

could into the manual control of both the camera and the flash, dedicating some of the preliminary sections to this—along with many sections throughout the rest of the book. With this extra help, photographers of any skill level should be able to follow along quite nicely. If you're already "in the know" and have tons of experience shooting manual, feel free to jump ahead (although a bit of a refresher is never a bad thing).

This high-drama photograph was made using a simple approach. The photographer simply dialed in an aperture that gave him the deep depth of field you see here, a shutter speed that allowed for the mood, a white balance that offered a bit more red than usual, and a saturation setting that enriched the image. He then used an off-camera flash on a stick to illuminate his subject from the right.

MANUAL IS MANDATORY

Buried under all the special shooting modes and automated features is the manual mode. This is where the journey to artistic freedom truly begins. The confidence, pride, and vision that come from this setting allow our own individuality and creativity to shine through. It doesn't create problems, it launches ideas.

First, it's about controlling depth of field, switching between aperture settings to blur out backgrounds or bring them into crisp focus. This alone marks a creative turning point; you are now creating, not just reacting. Next comes shutter speed control, perspective adjustment, composition, and design.

As your confidence with manual control rises, so will your expectations. You'll find that you demand even more from your camera. Your experience will allow you to be even more creative—you'll push yourself as never before, learning to adapt to almost any shooting situation, tossing around contrast, saturation, and white balance settings like play toys.

With a flash stick you can cut through the mire of ordinary photography and create stunning images in record time. You will be able to get amazing color, maintain perfect depth of field, and eliminate glare—even on eyeglasses.

As an artist with a camera, you will come to a point where you realize that natural light alone cannot help you reach your vision. You'll need to add light—controlled light that creates spectacular shadows with no glare and keeps your vision in focus. In this image, a flash stick proved essential. It let us wrap the light around the front support beam, giving our image depth, and also created the spectacular shadows you see—a very important feature of adding light with a flash stick.

CREATE AN IMAGE, DON'T JUST SHOOT A PICTURE

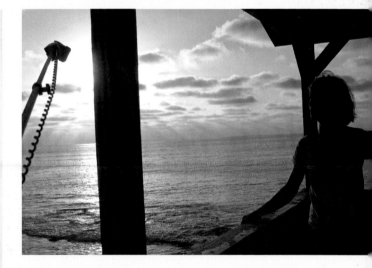

Adding light with a flash stick is the last step in a fascinating and liberating in-camera procedure. You can and should pick your own contrast, saturation, white balance, tint, hue, and even sharpness settings in-camera before you take the picture. Yes, the standard approach is to correct images after the fact, but if your picture is perfect right out of the camera, then what's left to fix?

Aperture

To use the flash well, you need a thorough understanding of the controls we have for collecting light—and what the artistic consequences of changing them will be. There are three camera settings to consider: the aperture, the shutter speed, and the ISO. Let's look at these controls, beginning with the aperture.

The aperture is the opening in the lens that lets light enter the camera and strike the image sensor to record an image. The size of the aperture can be varied for technical and creative reasons.

Depth of Field

Larger apertures are used to blur backgrounds and foregrounds—an essential option for creative photography. Using a large aperture can pose a problem for flash photography, however, since the shutter speed is limited by the camera's flash sync speed. One solution (with some flash/camera combinations) is to use the high-speed flash sync option. Alternately, neutral density filters or an inexpensive variable neutral density filter (called a fader) can be used take away the excess light.

Amount of Light

The size of the aperture also affects the amount of ambient light that enters your image and the apparent light produced by your flash. Smaller apertures, for instance, will take away light from your background and whatever your flash is lighting. For flash stick users, this means you can take quick control over the overall lighting by making an on-camera aperture adjustment—without touching the flash.

Larger apertures are used to blur backgrounds and foregrounds. In the top image, we see the effect that a large aperture (f/1.4) created. In the center image, a much smaller aperture (f/5.6) was chosen. For the bottom image, the lens's smallest-available aperture (f/16) was used.

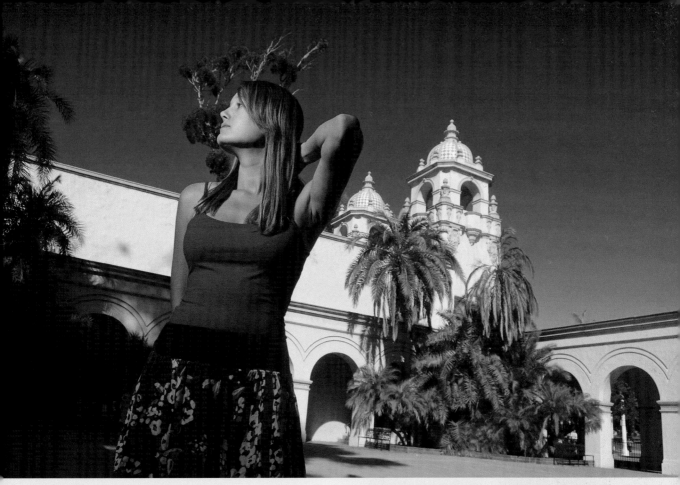

Being well-versed in the manual use of the aperture will prove essential to your growth as an off-camera flash artist. In this series of photos, the artist simply adjusted her aperture to quickly eliminate light from both the background and her flash. The eye-popping color came from her use of a polarizer (see page 50).

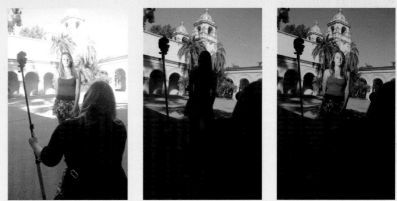

OTHER FACTORS IN DEPTH OF FIELD

Depth of field is controlled by three factors: the aperture (as discussed), the focal length of the lens being used, and the focus point. Larger apertures, longer focal lengths, and shorter focus distances all give you less depth of field. This means that the closer you are to the subject you're focusing on, the more you zoom, and the bigger the aperture you use, the more you can blur the foreground and the background. The farther away you are from the subject you're focusing on, the less you zoom, and the smaller the aperture you use, the more things will be in focus throughout your image. With all three working together, an artist can't fail.

Shutter Speed

In addition to the aperture, the shutter speed (the length of time the camera's shutter remains open, allowing light to strike the image sensor) offers another way to control your image.

Motion

In available-light photography, shorter shutter speeds are used to freeze action; longer ones are used to blur it. For flash photography, your subject (so long as it is lit only by the flash) can't be blurry—no matter how fast they (or you) are moving. This is because the burst of flash itself lasts just a tiny fraction of a second.

Many scenes, however, contain both flash and ambient light. If, under these conditions, you move your camera during a long exposure, whatever is lit by ambient light will blur, while whatever is lit by flash will freeze. This makes shutter speed a powerful creative option for the flash photographer. (See page 60 for an exciting experiment that combines the freezing power of flash with the blur of a slow shutter speed.)

LEFT—The camera was rotated during a longer exposure. The flash froze the model, while the ambient light blurred the background.

BELOW—These images illustrate the use of fast and slow shutter speeds with available light. In both images, the model was turning quickly. In the left image, the shutter speed was $^1/_{640}$ second, freezing almost all the motion. (The background/foreground blur was accomplished by shooting at a large aperture of f/1.4.) In the right image, the shutter speed was $^1/_{15}$ second, which allowed significant motion blur to record in the frame.

By making a small adjustment to a longer shutter speed, the photographer increased the brightness of the ambient-lit background without affecting the exposure on the flash-lit subject.

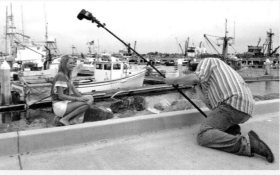

AMOUNT OF LIGHT

The shutter speed is one of the most powerful options a flash stick artist has because it can change the exposure level of the background while having absolutely no effect on the flash-lit subject. This gives you tremendous flexibility—by moving just one finger. If you want the background to be slightly brighter, switch to a slower shutter speed setting to let more ambient light record on the background (leaving the subject lit perfectly by the flash). Conversely, switch to a faster shutter speed to make the flash-lit subject stand out against a darkened background.

ISO SETTING

Adjusting the camera's ISO setting is another way to control how bright or dark our images will appear. This provides a wealth of options for the forward-thinking manual shooter. If a higher ISO were chosen, then faster shutter speeds or smaller apertures could be used to garner the same amount of "apparent" light. Of course, this approach does have its drawbacks. As the ISO increases, the unpleasant digital noise and loss of contrast often become unacceptable.

RECIPROCITY

When you adjust one of the exposure controls on your camera, you must make an opposite change to one of the other controls in order to maintain the same exposure level. This inverse relationship between your camera's exposure controls is known as the law of reciprocity.

For example, if you "open up" your aperture from f/8 to f/5.6, you will be adding light to the exposure and must "stop down" your shutter speed (reduce the length of time the light strikes the sensor) by one stop. This means you might need to adjust your starting shutter speed of $\frac{1}{125}$ second down to $\frac{1}{250}$ second.

Conversely, if your creative vision requires you to use a smaller aperture to keep more of the scene in focus, you'll have to use a slower shutter speed. But there could be a problem: if you want to open up your aperture to blur out the background, your moving subject may also become blurry with the slower shutter speed if you need to maintain a "correct" exposure.

A VITAL CONTROL

Understanding reciprocity will prove a vital skill when shooting in the field with a flash stick. You'll be required to make quick adjustments to the aperture, shutter speed, and ISO in order to control the depth of field, the background exposure, and the apparent power of the flash. Fortunately, all of these adjustments can be done with a simple movement of your finger or thumb. For a seasoned flash stick artist, there is very little need to pull the

TOP—In this ambient-light image, we see the result of a very large aperture (f/1.4), a fast shutter speed ($\frac{1}{200}$ second), and a low ISO setting (200). To get more depth of field, some changes had to be made.

BOTTOM—After shrinking the aperture to f/5.6, we needed to add light. We could have done this by slowing the shutter speed to $\frac{1}{13}$ second (replacing the light taken away by reducing the aperture). However, the wind was blowing and a slower shutter speed would have created blur. Moving to ISO 3200 allowed for both the increased depth of field and the shutter speed needed. We did take a big hit in quality, though.

The photographer chose the settings he needed to create a moody background. If the aperture had been off for the flash, he could have adjusted it, then made a reciprocal change to the shutter speed to maintain the desired exposure level on the background.

flash back and make any adjustments to the flash once the initial power setting is made.

It's a dance of options that can't be done in any automated approach. You really have to understand how photography works in order to use the flash stick well.

IN PRACTICE

Let's look at how this plays out on a real shoot. For this image (right), we began by visualizing our background. We wanted an in-focus, dark and brooding atmosphere. To get it, we picked the appropriate aperture, ISO, and shutter speed settings—as well as specific white balance, contrast, saturation, and sharpness settings for the look we wanted.

The next steps were to check the depth of field using the depth of field preview button, set the flash power (based on the aperture size and overall spread of light desired). The photographer then held the flash stick high and to the left of the subject and fired. This flash position illuminated the subject perfectly, creating the dramatic shadows you see.

If the flash power setting had been wrong, he could have moved it either closer to or farther away from the subject—or he could have changed the aperture to take away apparent light from the flash (making the appropriate shutter speed change to keep the background the same).

There is nothing inherently difficult about this process, it's just that you need the vision to start with. You have to see beyond reality, understand your gear, and then just add some light.

Adding Flash: Power

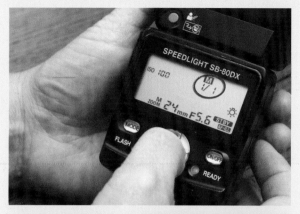

When you add light by introducing flash, you walk away from the restrictions that reciprocity demands. Therefore, using flash can help you be a real artist with your camera.

We add light for a number of reasons, many of which we'll be discussing in this book. For now, let's just look at the tool itself and understand how to control the amount of light (power) it emits.

Real Power Adjustments

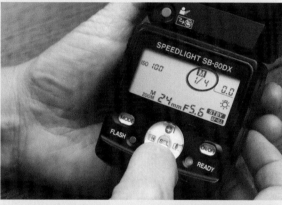

Most flashes allow for the manual control of the power itself (*i.e.*, how much light the flash emits). There are usually several power options, including full ($^1/_1$), half ($^1/_2$), one quarter ($^1/_4$), and so on.

By adjusting the power setting, you are making the flash stronger or weaker; you are not making it softer and harsher. The power setting on your flash only affects the distance the light will travel. It has nothing to do with how "pleasing" or how "soft" the light will be in your image.

Apparent Power Adjustments

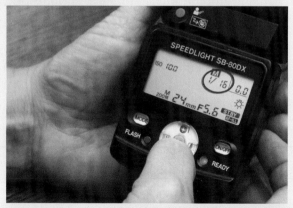

Adjusting the power setting of your flash is the only way to adjust the "real" power output of your flash. There are, however, several ways to adjust the apparent power of any flash.

On this Nikon SB-80DX flash, the user can choose settings ranging from full ($^1/_1$) power all the way down to $^1/_{128}$ power. The settings shown are just four of the many options available.

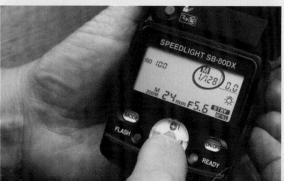

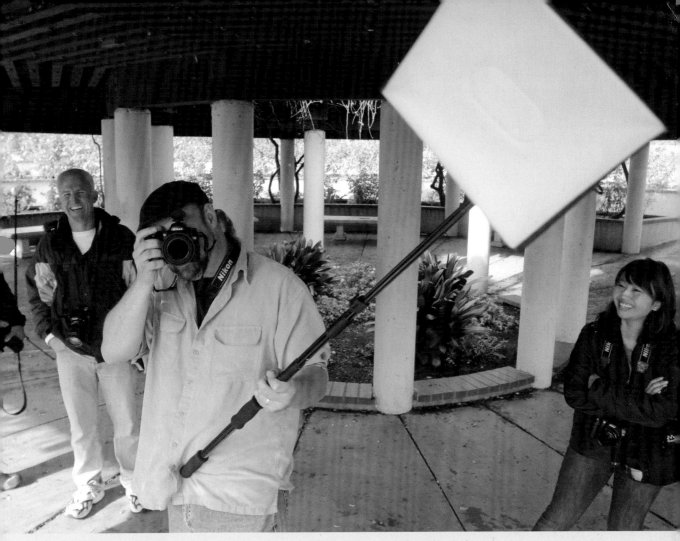

Scattering/diffusing modifiers make the light from the flash softer, but they also reduce its apparent power on the subject.

Distance from the Subject. If the flash is closer to your subject, you will gain apparent power. Your subject will be brighter.

Aperture Size Chosen. Smaller apertures cut the amount of apparent power coming from your flash, while larger apertures increase it.

Zoom Feature Engaged. Many flashes offer a zoom feature, which allows you to narrow the beam of light. Since less light is wasted, zooming gives you an apparent boost of light. Your subjects get brighter.

Modification Tool Used. When using an umbrella, softbox, or other scattering/diffusing modifier on your flash, the light will be weakened. Using a snoot to corral the light (similar to the zoom feature) will increase the apparent power of the flash.

Bouncing the Flash. When using a wall, ceiling, or bounce tool to enlarge your flash, you run into the same apparent power reduction as with scattering/diffusing modifiers. The larger you make your light, the less "apparent" power you have coming out of the flash unit itself.

FILL THE BUCKET

Flash photography requires critical thinking. We use a bucket analogy when describing the process. Think of your camera's sensor as a bucket. There's a lid on this bucket with an opening in it. Now, think of ambient light as water from a hose.

You are outside and holding a garden hose as you fill your bucket. You turn the faucet and water begins pouring. What will it take to fill the bucket? There are a few factors to consider.

One issue is the size of the hole in the lid. A larger opening allows water to gush through quickly, while a smaller opening only allows the water to trickle through slowly.

If your bucket has a large opening in the lid, then the amount of time required to fill the bucket will be short. This is equivalent to using a wide aperture with a fast shutter speed. If your bucket's lid has only a tiny opening, the water will trickle in slowly, and it will take a long time to fill the bucket. This is equivalent to using a tiny aperture with a slow shutter speed.

In both scenarios, you'll end up with a full bucket—but you can see that one decision (the size of the opening in the bucket lid) affects the other (the total fill time).

There's one more factor: How big is the bucket? A small bucket doesn't require a lot of water to fill; that's akin to a high ISO setting on your camera. A larger bucket, on the other hand, will take more water to fill, like a low ISO setting.

This is how it works in photography. After the ISO is set, the aperture is the next creative choice, since this controls the depth of field. The shutter speed is a consequence of these two decisions.

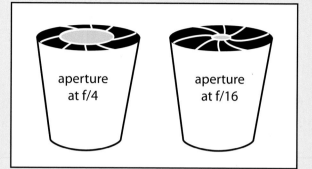

The size of the lid opening on your bucket will control how fast water can pour in.

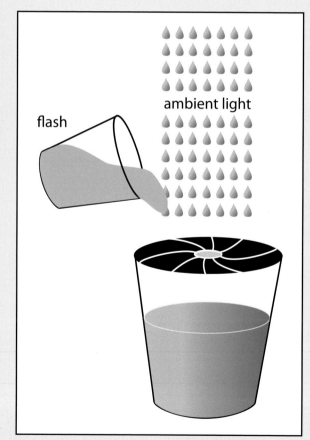

Adding flash is like having an extra container of water on hand—but the size of the aperture will still control how much of it gets into the bucket.

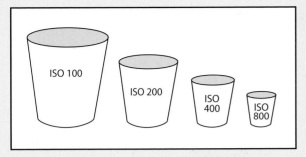

The capacity of the bucket (akin to the camera's ISO) determines how much water will be needed to fill it.

Flash photography simply continues the idea—it's like having an extra container of water on hand that you can dump into your bucket at any time. You may add a lot of water or just a little.

This is another reason the choice of the opening size (the aperture) on the bucket lid is so important. If you were to pour that additional container of

With the addition of light from a flash stick your options grow exponentially. You'll have positioning choices most photographers can only dream of—and check out the absence of glare on the eyeglasses!

water (flash) into a tiny hole, only a very little bit would make it through. If you were to choose a smaller aperture, you would then need to boost the amount of water coming in (the flash power). Plus, you are still responsible for filling the rest of the bucket with the ambient light.

It's no wonder that many people give up on flash photography before they even begin. But with enough practice, anything is possible. In no time, you'll be controlling both the ambient light and flash in your images, creating amazing photographs and changing the way reality looks.

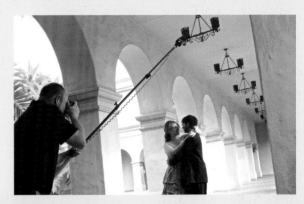

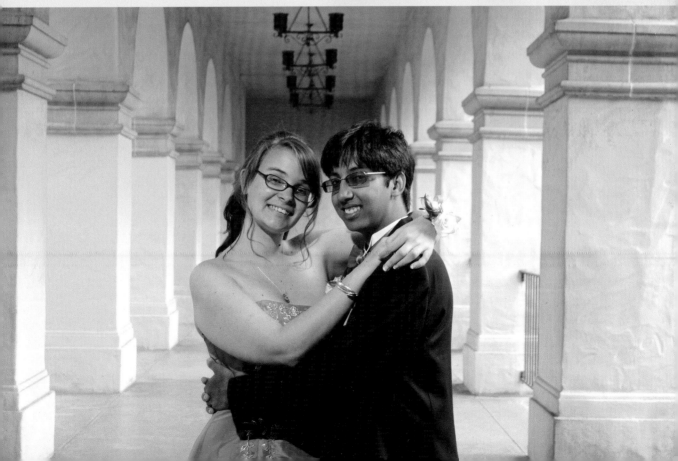

Message-Building

While photography is an art form, there is also a certain sense of structure to it—a path that one follows to create spectacular images. It's the same for any artist. A painter opens his paint box, applies some paint to a palette, chooses a brush, mixes the colors, and begins creating. Photographers do the same thing, choosing tools in a certain order. You pick a memory card, insert a battery, choose your lens, adjust your flash and so on. We accept this as part of being a photographer. But did you know that there are a few other things you could be choosing as well? A deeper path to follow? Here's how to do it.

Creativity Is Not In Your Camera Bag

Most people, when searching for the path to artistic expression, look to their gear for the answers. They spend an exorbitant amount of money on cameras, lenses, and flashes in the hope of being more creative. They read the reviews, ask the experts, and look for deals. Their heart is in the right place, but their direction is flawed. Creativity and artistic pride can't be found in a camera bag; those things are inside the person. They come from experience, from knowledge, from confidence; they are gained through repetition, foresight, and vision. It can't be bought.

Start with an Idea

Decide what it is you want to say—or at least have a basic idea. Think about how this image should appear, how it feels to you. Then dial in the contrast, saturation, and white balance settings you need to produce that feeling. (We realize that most photographers do this after the fact using a computer. But when do you think you are more in touch with how something makes you *feel*—when it's right in front of you or days later when you get around to opening the image on your computer?)

Compose the Shot

Choose your camera position for the desired perspective. Line up each graphic element, from the front of the scene/subject to the back. Move forward and backward to change the relationship between those graphic elements if necessary.

Select a Lens

Once you've picked a shooting position, choose the lens or focal length that offers the crop factor you need. Come as close to perfect as you can. Don't allow anything extra into the frame that may detract from your message. This is the sign of a true artist with a camera: using everything within frame but not allowing in any distractions.

Set the Aperture

Pick an aperture that gives you the right depth of field. Look through your viewfinder and think about the graphic elements that you just lined up. Which do you want to be sharp and which do you want to be blurry?

SET THE SHUTTER SPEED

Choose a shutter speed that best illuminates your message. This is the tricky part. If a slow shutter speed is required, you could simply dial it in. However, as the shutter speed slows, you run the risk of a blurry photo. To compensate, you could raise your ISO—but this will also affect the overall quality of the image. As the artist, you have to make the choice: do you risk the blur or do you raise the ISO?

CONSIDER ADDING LIGHT

Let's say that you choose a shutter speed that gives you an amazing background—but it leaves your foreground element in shadow. You can't simply adjust the shutter speed or ISO to fix this without affecting the background as well. This is where the flash comes in. Because flash offers a creative solution to so many lighting situations like this, it is the single most important paintbrush you will ever use. It makes possible anything you can imagine.

The first image (far left) reveals how the world actually appeared. The second photo (near left) shows our manual choices set in-camera. The final photo (below) illustrates the power of adding a flash stick. Yeah, this tool *does* make a difference!

THE RIGHT TOOL

Yes, using a flash stick can be a bit awkward. Not only do you have to hold your camera with one hand and balance a flash set upon the end of a stick with the other, but you're still required to visualize an image and make all the needed exposure adjustments beforehand. In addition, you've got to do it quickly, confidently, and remain focused enough not to hit someone on the top of the head. Nothing says failure quite as loudly as when you pop your model in the forehead with a 10-foot-long metal light stick. Ouch!

However, if you truly want to stand out—if you're ready to create some of the most fantastic images you have ever made with your camera and don't mind a few stares coming from curious onlookers—then get ready for the ride of your life. What can be accomplished with a light stick (without the need for an assistant or a studio) is amazing. It will change the way you approach message-building with a camera. That's a promise.

IS IT REALLY BETTER THAN A LIGHT STAND?

Light stands have been around for ages, but doing something active with them in the field—making them a completely moveable piece of the lighting puzzle—is something brand new. As more photographers today take up the challenge of off-camera flash photography, they are looking for bigger, brighter, and bolder ways of using that light by themselves. Using a flash stick does just that.

The ability to add as much light as you want, from any angle, while in the field and by yourself is something very new—and it will change your images forever. Here, the flash was actually 15 feet above the water. There's no other tool that can give you this light!

Building the Stick

A flash stick needs to be a sturdy tool—one you can trust to support your light. More than that though, you need a flash stick that gives you the reach you need, is easy to carry, and allows for comfort of use at any length. The last thing you want is to have to strain anything when you are shooting.

We recommend starting with a typical (and inexpensive) 7 to 10 foot light stand; this will be repurposed into your first flash stick. Diameter is key when choosing a light stand. A pole with a 1-inch diameter is perfect. Anything thicker (or thinner) is uncomfortable to hold and will not be as controllable.

You will need to remove the legs from your light stand. Often you can simply unscrew them, though you may need to get a bit more aggressive with some stands. We've been known to knock the legs off of a light stand with a hammer if need be. The rivets used are often not of the best caliber, and

LEFT—Removing the legs from a light stand.

BELOW LEFT—Tapping down any rough edges with a hammer will make your light stick nicer to use.

BELOW RIGHT—A rubber cap is useful for covering the bare metal bottom.

Rubber shelf liner (available at all hardware stores) works great as a grip. We glue it on with oil-resistant adhesive. When you're done, you'll have a long light support that's light and easy to hold.

the legs will usually pop right off with one good whack.

You can try using a monopod as a flash stick, though the weighting of the tool usually doesn't work well. The thinner bottom portion makes balance and movement a bit more difficult. A tripod may also work, if it is small enough.

If you decide to use the recommended light stand, once the legs have been removed you'll want to cap the end of the stand with a rubber tip (available at most hardware stores). This is important since the metal will be bare and you'll

be putting that part of the flash on your hip. You may also want to put some type of "grip" on the flash stick. We use rubber shelf liner. Cut a small piece and wrap it around the stick near the end of the first extension. We affix it with a quick-drying, oil-resistant adhesive.

The key to effectively employing a flash stick (as these students are discovering) is in using a very lightweight, yet durable, repurposed light stand.

You Want Me to Do *WHAT?*

Yes, when you make a light stick, you "ruin" a light stand by taking the legs off. If using the word "repurpose" makes you feel better about destroying a perfectly good light stand, then try that. (This is why we suggest using a relatively inexpensive light stand.) Remember, you are creating a new tool that is unique. It is no longer a light stand; it's a flash stick.

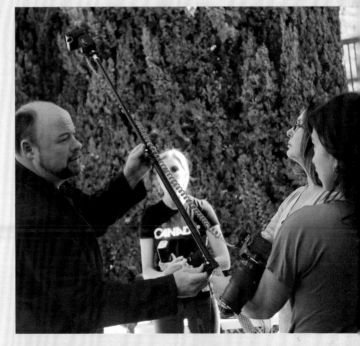

COMMUNICATION

Your flash and camera will need to talk to each other in some fashion. This is a necessity for any type of off-camera flash work that doesn't involve super-long exposures.

A Wired Approach

A long TTL cord is preferred by most shooters when using one flash. The cord maintains a full electrical connection between the camera and flash, preserving advanced features like high-speed sync.

Cord length is important. If it's too short, you won't be able to take advantage of that extra distance a good stick offers. If it's too long, the

The completed flash stick using the wired approach.

cord drapes over the scene (and takes up too much space in your camera bag). For a 7-foot flash stick, we use an 8-foot cord.

A Wireless Approach

For wireless communication, you can either use an optical system or a radio triggering system. The radio triggering system is very reliable. We have used the Cactus brand radio system for years; as long as the batteries are fresh, it works like a charm.

You may already have an optical triggering system built into your own equipment. This approach is great for work with a flash stick, since the optical trigger (typically your pop-up flash) will be relatively close to the off-camera flash.

After attaching a radio receiver to the flash via the PC connection, we secure the receiver to the flash with a rubberband.

To use a TTL cord setup, start by attaching the flash to the cord. Then attach the unit to the flash stick. Finally, attach the cord to the camera.

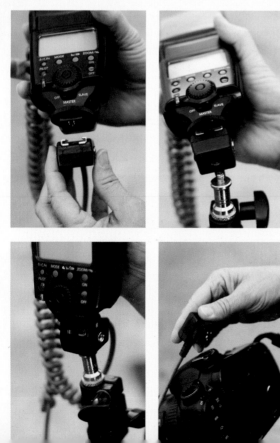

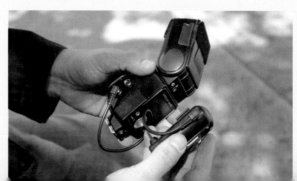

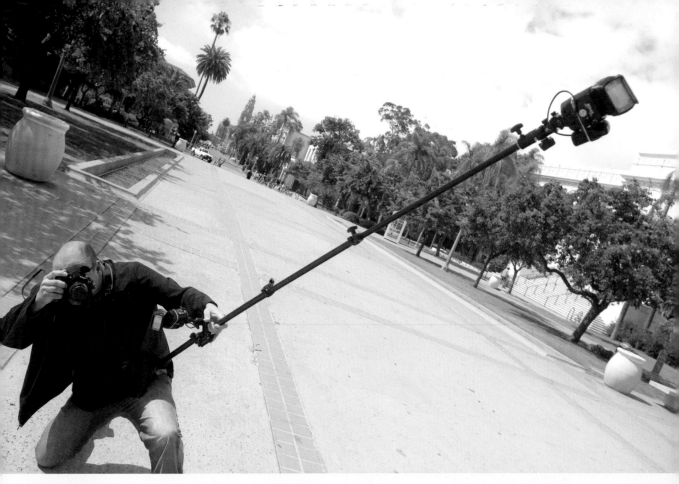

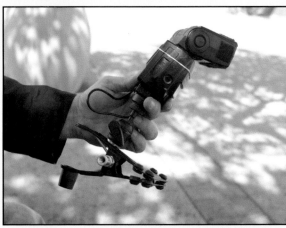

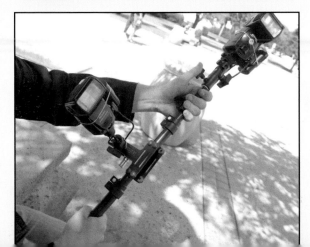

TOP LEFT—An inexpensive clamp adapter will let you add another flash to your flash stick. **BOTTOM LEFT**—Here, we see a flash and wireless receiver being attached to a flash stick. **ABOVE**—The wireless, two-flash flash stick in action (the second flash is close to the bottom of the stick).

CONNECTIVITY

Attaching the flash to the stick is simple. With a wired approach, many flash models can be attached directly to the stick. With a wireless approach, you just need some type of inexpensive flash bracket. Make sure that the bracket you choose is equipped to hold an umbrella, as light modification may be a key component later. You can also use flash clamps, flash mounts, flash "shoes," or a variety of other devices built to attach a flash to a light stand.

Controlling the Flash

Once your flash and camera are "talking" to each other, you'll need to get used to shooting with just one hand.

Holding the Flash Stick

Start by just holding the flash stick when it's fully extended. (Make sure the flash is secure.) Grip the flash stick below the first extension, placing the end of the flash stick on your hip or thigh, whichever feels more comfortable. Hold the stick firmly. You will feel the weight of the flash on your hip or thigh. Your hand will be working as a pivot point between the two ends allowing you to manage the weight at the top of the stick efficiently. By moving your hand up or down and then making the appropriate change in the position of the stick on your hip or thigh, you are turning the flash stick into a lever—onto which you can add quite a bit of extra weight if you like. Just steady the tool and point the flash at what you want brighter.

Holding and manipulating the flash stick is extremely simple and quit intuitive. Since the weight of the equipment is on your hip, not in your hand, your equipment will seem lighter the higher it gets. The more you stretch it out, the easier it is to use.

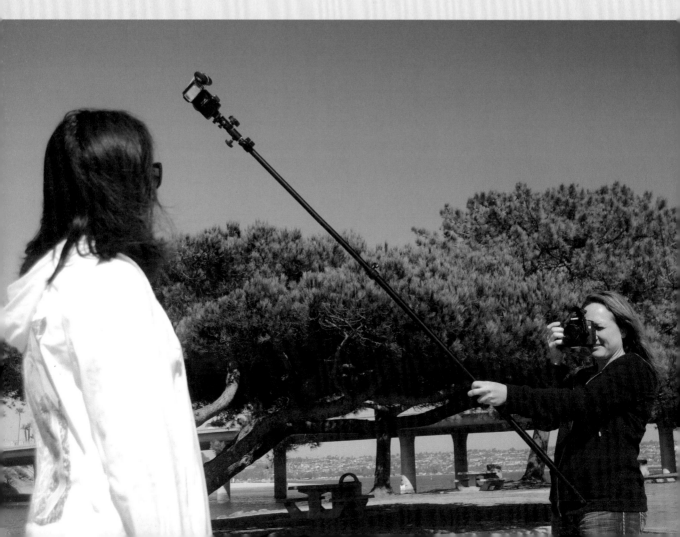

Keep It Simple

Shooting images with just one hand will complicate matters, but you can make it easier on yourself with a few simple choices.

For starters, use autofocus when shooting with a flash stick. We are huge manual fanatics (even when it comes to focusing), but here even we have to give that up. Without a third hand, manually focusing your camera while holding a flash stick is extremely difficult. (Although when using the "short stick" technique [covered later in the book], you'll still want to be in manual focus.)

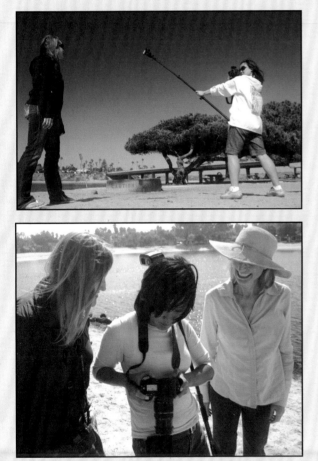

At first, you'll want to practice simply manipulating the flash stick. Attach just one flash and get to know what it offers. Move it around a bit. Feel the weight. Find a balance point and adjust its angle. When you're ready, start shooting and check your results.

Portability

You can see how easily the flash stick attaches to a camera bag. It can ride quietly on the front or back of the bag in this manner—but you are free to design your own holder.

You'll also want to have all your settings dialed-in *before* you begin shooting. This includes aperture and shutter speed choices, flash power options, and internal settings such as contrast, saturation, white balance, and hue.

Confidence always plays a key role in creating with an off-camera flash. If you're not comfortable with full manual control of your gear, get that way. It will make any work you do with a flash stick that much easier—and that much more rewarding.

Prepare for Onlookers

Is It Magic?

When your friends ask you what kind of camera you have or beg to know what kind of flash gave that soft glow, don't be too upset. Just smile and explain that it's not the camera that makes the magic, it's the artist. If they don't believe you (and they won't), you can try to elaborate—but don't expect quick acceptance. To address the question, simply point to the flash stick attached to your camera bag, smile, and give a slow, meaningful nod. This will fill them with curiosity and give them a bit of insight; you will make your artistry known.

Before we go too much farther, let's take a moment to discuss a side effect of shooting with the flash stick: you're going to get some strange looks and questions.

People *will* stop and stare. Let's face it: what you're doing looks a lot more interesting than what they're doing. Even if they're taking pictures in the same area, it's going to be pretty clear that you're going out of your way to create something special. Using a flash stick sets you apart.

This can be fun if you like the attention—but if you're shooting with a model, don't forget his or her feelings. You've made a spectacle of yourself *and* your model. From their perspective, the eyes of the world (along with a very dramatic flash) have just fallen on them—and they're right.

Be honest with this fact. Accept it, and let your subjects know what they can expect on shoots where you'll be using a flash stick. Then deal with their feelings (and any onlookers) in a professional manner. It's also a good idea to develop a list of places where you can expect to shoot without encountering many spectators. Choosing a location where your model will feel at ease works wonders for your images.

Faith, confidence, and honesty go a long way when working with clients, models, or family members as subjects. They need to know that you know what you're doing with that strange-looking flash stick and trust that you're using it for a reason.

FACING PAGE—The first few times you take the flash stick into the field, choose a quiet place where few will stop and stare.

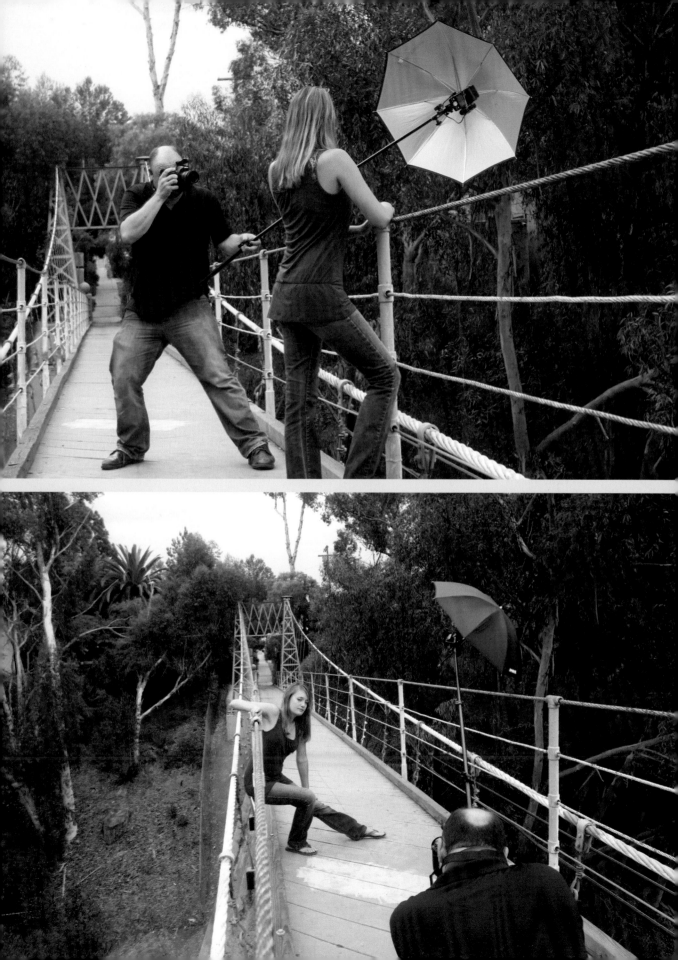

A Patient Model

Practice really does make perfect. This is especially true when it comes to off-camera flash photography and when using a flash stick; with so many variables kicking around, it's vital to get in enough practice before you start shooting in the "wild."

Wig Heads

When learning to use the flash stick, it's imperative to find a model who won't mind if it takes you twenty minutes to get your shot. Wig heads are awesome for this! Not only do you get to see how the shadows from your flash will fall, but the pure whiteness of them makes it possible to see the results that much more easily. Visit any beauty supply store and you'll have several options. We suggest purchasing one that closely represents the features of a human head.

Next (as odd as it's going to sound), you'll want to put that head on a stick. We use a light stand. The wig head already has a hole in the bottom and it fits perfectly, sitting several inches down on the stand. With this kind of setup, there is no need to worry that the head will blow off in a breeze; it's there until you take it off. (Plus, the whole thing will freak out your neighbors—an added bonus!)

Having the perfect model will help tremendously. We suggest "heading" to the local beauty supply shop, where you'll find a plethora of willing models—most for less than $5 each.

LEFT—We always suggest the use of friendly, patient models.

RIGHT—You've got to get comfortable with the gear before you can employ it well. The photographer in this image is using a Cactus brand radio transmitter and receiver for a wireless connection between her camera and flash.

NOW, WE BEGIN

To see students grow—to see them make mistakes and fight to fix them on the spot—there really isn't anything more spectacular for an instructor. On the flip side, there is probably nothing more unnerving for the student than to be handed a flash and be told, "Now, go shoot." To help, we offer some simple exercises. Usually we begin with the very basics—the issue of light. The first step is to have our students get rid of it. That's just what we'll be doing in the next section of this book, so keep reading!

Flash Practice

The First Step

Let's start by making everything black. Dial in your camera's smallest aperture setting, then set your shutter speed to your camera's flash sync speed (check your manual if you are unfamiliar with this). Choose a very low ISO (100 or 200) and take a test shot outside. Your image should be very dark—if not black. This is just what you want; it will help you see the effect of your flash with little to no ambient light getting in the way.

Now, place your model several feet away. Attach your flash to the flash stick, angle the flash to 90 degrees, and turn the power of your flash unit to full. Extend the stick until the flash is aimed directly at your subject. Take a mental note of how close

Analyze your images and learn what to expect from your flash *before* you shoot. This is one form of visualization—and you'll be using it every time you shoot. Pay close attention to your results.

the flash is to the head. Feel the weight of the stick in both your hand and on your thigh. Memorize this balance point and fire.

Your first shot should be very telling. Depending on the actual power coming from your flash, the aperture available, and how close you held the flash to the model, the head may be very bright, just perfect, or not bright enough. You will need to adjust one or more of the above controls to create the perfect light for your model.

Our suggestion to new students is to start by simply adjusting the power on the flash unit itself until the lighting is perfect. Get to know what flash power setting works at what distance when a given aperture and ISO are used.

Checking the LCD, scrutinize the images you shoot. Don't stop tweaking the settings until you create the perfect image. Remember that the pictures don't matter and your model doesn't care. Take your time and learn from the process.

Once you have a good handle on the power settings, change your approach by varying the distance of the flash to the subject. This is a very practical technique and a bit more realistic; when you're out in the field, you won't want to reel back the flash to fine-tune the power settings. A slight movement (either closer to the subject or farther away) will garner very similar results.

Going deeper

Keep your settings where they are and light your subject from the left with your flash stick. Make it perfectly lit. Examine the image again, but this time look specifically at where the shadows fall.

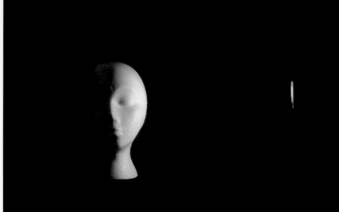

Think about the shadows you created and compare them to how the subject may look in normal light. Did you change anything? Is your version of reality (besides the black background) different? The answer is yes—it is.

As you can see, the shadows now fall on the other side of the face and, depending on the angle of the flash, these shadows can be delicately moved about. You can also make slight adjustments to your own shooting angle to change them.

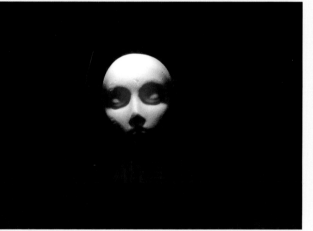

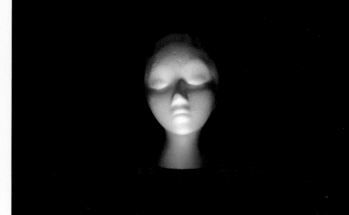

In the first image, the light was placed above the subject; in the second photo, the light was placed below.

Now, try a crossover. Slowly swing the flash (don't hit your model) to the opposite side and fire. Examine the results.

Then, change the light again. Put the light above and below your subject. Place it in the corners. Move it slightly closer and farther away.

What you're building is practical experience—something that most professionals cherish. It's not costing you anything and you can shoot as long as you like. Learn as much as you can from each setup.

Your Ace in the Hole

You do have an ace in the hole when it comes to adjusting the apparent power of a flash. One quick change of the ISO setting, making it either higher or lower, will drastically alter the appearance of any light captured by the camera—including that created by your flash.

Basic Modification

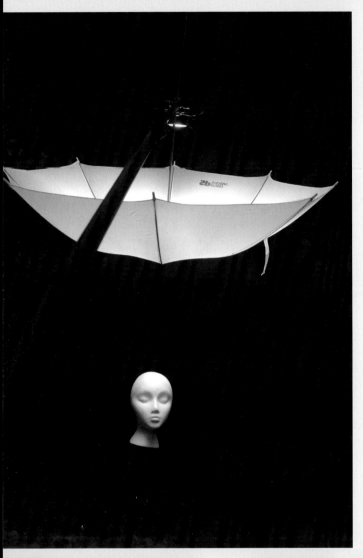

By enlarging your light source, you produce a greater area of flash coverage. You can garner the same results by pushing your flash farther from your subject or by using a wider zoom setting on your flash—but the accompanying loss of power is usually not welcome.

Instead, photographers use softboxes and umbrellas to enhance their flash coverage. This comes with the added bonus of cutting back on the glare the flash creates. (Keep in mind, though, it does not eliminate it; the only way you can do that is with a polarizer—more on that later.)

A flash bracket that accepts an umbrella is relatively inexpensive—as is a shoot-through umbrella. With the umbrella attached, repeat the exercises from the previous section. You'll quickly notice the difference. Not only will your flash cover a much larger area, but your flash power requirement will also double. Whenever you modify a flash by enlarging it, you are giving up some power as the light travels to farther areas. You can compensate with adjustments to the flash power, flash-to-subject distance, or ISO setting.

As you can see from these images, the area of coverage expands when an umbrella is employed.

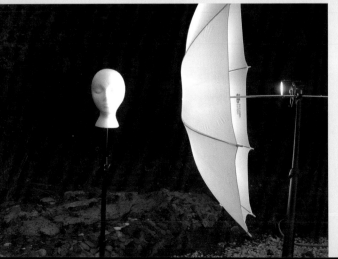
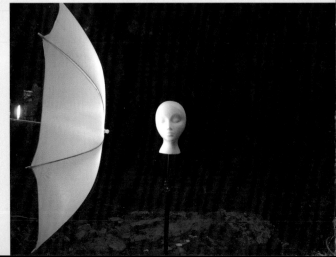

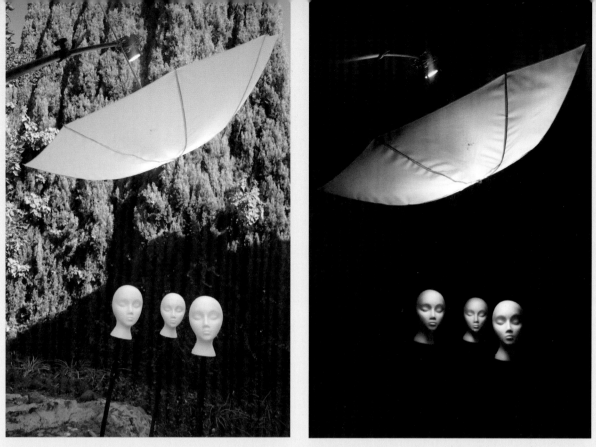

ABOVE—Since you now have more coverage area, try adding more subjects. Repeat the previous exercises to really see what is possible with your modified flash stick. You may be surprised at the results.

BELOW—Using an umbrella with your flash stick will change the weight of your equipment and throw your "memorized" balance points off. Practice this technique in a controlled environment before trying it in the field.

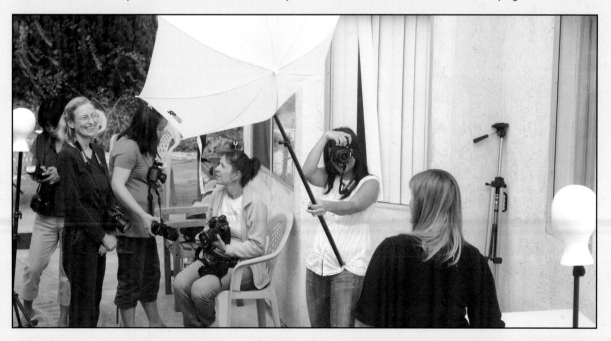

BEYOND BLACK

The goal of the previous exercises was to get you acquainted with what your flash stick offers—with and without modification. However, it's doubtful you'll want an empty black canvas behind *every* image you create.

In the previous exercises, we eliminated all ambient light to get that black background. If you want the background to be brighter, then you simply need to add in however much ambient light is required.

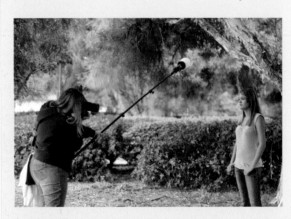

MIXING UP THE MODIFIERS

Beautiful light can come from any flash (no matter the brand or cost) and from many modifiers (no matter the brand or cost). Umbrellas are only one way to enlarge and diffuse your light. There are many others. If you don't own a modifier or two, buy some; explore all the sizes, types, and brands. You may find one you like, then two days later one you love. When it comes to gear, there is no right gear, no perfect flash, no correct modifier—just stuff you've played with and stuff you haven't. Here, an egg-shaped diffuser was used to illuminate the model. While this device wastes a considerable amount of valuable light, it does cover a large area—something that is often perfect for outdoor portraits.

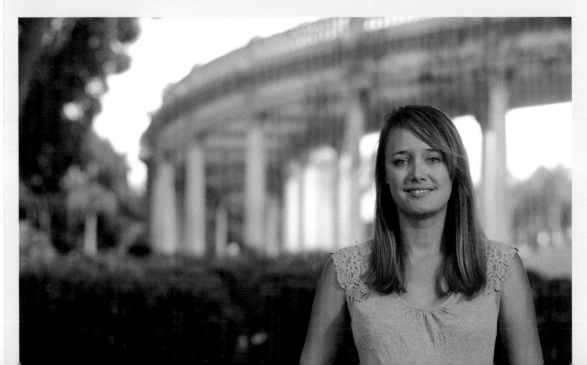

As you can see in this image, a large aperture was chosen to produce the blurry background. A relatively short shutter speed setting was picked to give the image a bit of mood. A modified flash stick was then called into play and placed above and slightly to the left of the model. The lighting in this image does not reflect reality. It was created with a combination of camera settings and light modification. You can't get this any other way.

Again, you have three choices: you can slow your shutter speed; you can adjust your aperture size; or you can raise your ISO. If you've already picked an aperture for the depth of field you want, the answer is obvious: just keep slowing the shutter speed until the background gets as bright as you want it. If you happen to reach a shutter speed that is too slow for your image (one that would cause unwanted motion blur), raise the ISO. Yes, it's that simple.

Now, try the previous experiment again, but this time with a live model (preferably someone who loves you dearly, since it may take a while).

Start with a black background and light your subject well with the flash stick (modified or not—your choice). Next, ever so slowly begin shooting images at longer shutter speeds to start adding light. Watch as your background begins getting brighter but your subject stays lit the same way. (It's really cool!) Keep adjusting the shutter speed until you think the background and subject look great together. Then, examine the image again. Scrutinize it. If you are unhappy with anything, make the appropriate adjustments. Once you've got that perfect shot, it's time to take your newfound skill into the field. Get ready to play!

The "Best" Time

ost photographers hunt for great pictures. They look for light and search for the mood they want—then they take pictures of things and places when everything is perfect.

Some professionals talk of the "best" time to shoot, insisting that morning light or evening light is perfect. That's fine—but if it's true, it's awfully sad. Imagine being able to shoot great photos *only* in the morning or evening, when the light is perfect.

The truth about timing is a bit easier to swallow. Light is light; it's neither bad nor good. It just illuminates. When natural light fails you, that's when you call on your flash, no matter what time of day it might be.

As artists, we don't have to wait around for the "right" light to happen or hunt for an image and then hope we have the gear to capture it (or a computer to "fix" it). We can create our own reality in the camera. We can force an image to appear the way we want with the gear we have—that's why we carry a flash! A flash (in case you didn't know) is not there just to eliminate shadows; it's there to illuminate our visions.

By simply changing your shutter speed you can make your background brighter or darker and adjust the feel of your image. The best part is that the shutter speed has no effect on the flash, meaning that you can experiment with various backgrounds without worrying about the light coming from your flash. Your subject stays lit well throughout the entire process.

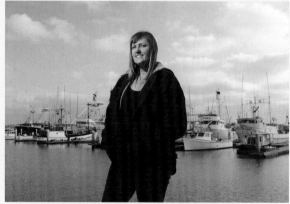

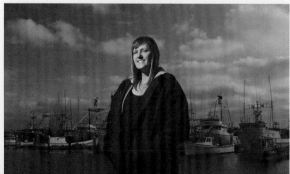

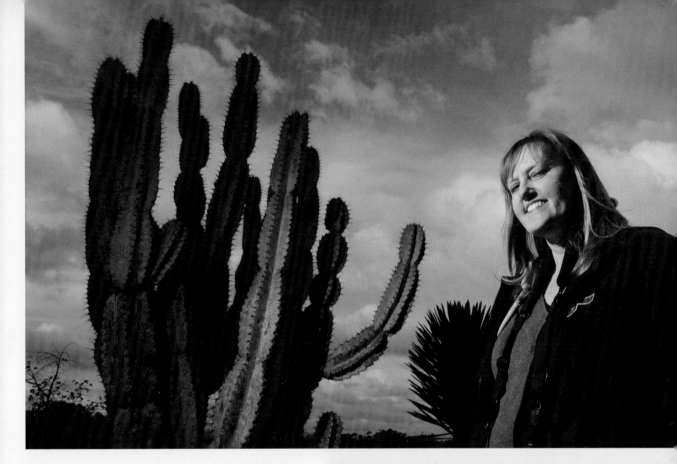

There is no such thing as the "perfect" time to shoot. The amount and quality of the light captured is, as it always has been, up to us as artists. If we don't like what the world offers, we can change it. That's the beauty of being an artist: you can stretch the boundaries of reality. When you ignore reality (right), you can create a new vision of life (above).

A Natural Approach

Creativity doesn't work on a schedule; it isn't dictated by lunar phases or what the weather or time permits. If the light that surrounds you isn't "perfect," you can use flash to make it that way. You can shoot at any time—day, afternoon, or evening. You can shoot in bright light, on a cloudy day, or covered in rain. Just adjust your camera settings and add light where it needs to be. In this way, the flash enables you to be fully creative. With the flash stick, you have the benefit of more reach—and this reach is important.

No Bad Time

There is no such thing as a "bad" time to shoot (despite what you may have heard). There are only bad photographers who don't know how to use their gear.

SHADOWS AND TEXTURE

The farther from the camera you can send your flash, the more creative you can be with it. That's not a boast; it's a fact. Not only will you be able to light other tiers of graphic information (elements in your composition beyond a simple subject), but you can also take control of the types of shadows you're making.

Shadows are an important part of how we process the shapes and spaces around us. Our minds use the interplay of light and shadow, on both a conscious and subconscious level, to tell us where we're headed. Shadows tell us where the sun is and where the ground is. We use shadows every second of every day, so we expect them to be there

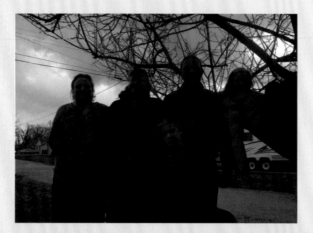

The flash was positioned above and far to the left of the family, creating depth and texture. The photo to the left illustrates our starting point. We could have easily dialed-in an aperture, shutter speed, and ISO combination to expose them perfectly without a flash, but our intent was not an ordinary photo—and the flash stick allowed us to pursue that vision.

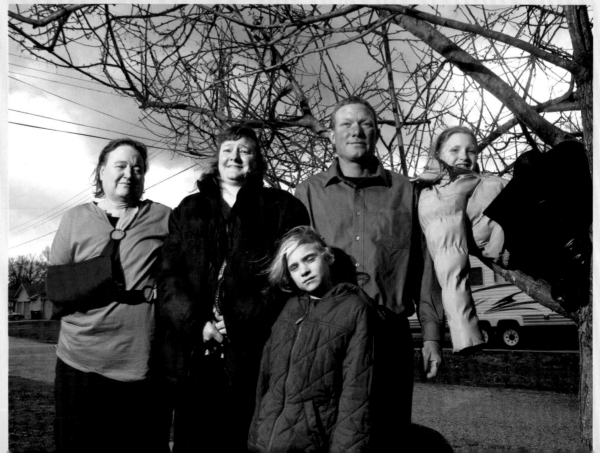

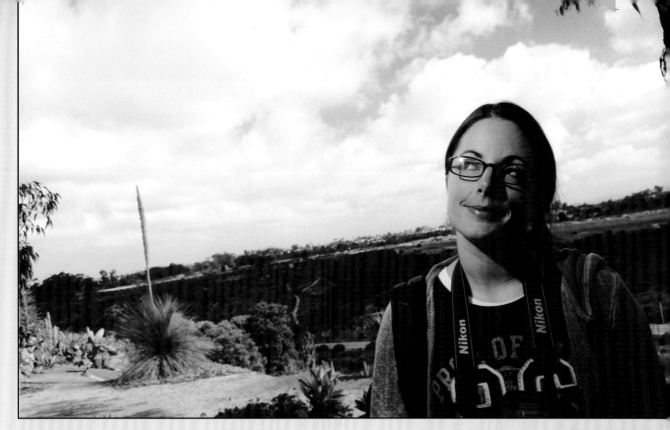

The flash stick can create very dramatic lighting. In the image above, it was pushed far to the left of our model. As a result, it created some rather dramatic shadows on the opposite side of her face. Notice we used the word "dramatic." Isn't that how you would want your images to be described?

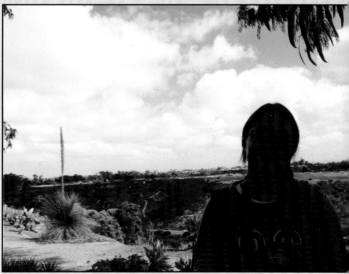

when we open our eyes. Shadows are as much a part of life as the colors that surround us.

This explains why most photographers choose to use their flashes off-camera; an on-camera flash eliminates shadows—it flattens things out or, worse yet, creates shadows that look very abnormal. We

PUSH IT

By pushing the flash as far from the camera as possible, you can adjust reality while still keeping things appearing as they should. The light you create will appear natural, even if that light and its shadows vary from their "real" surroundings. If anything, that just makes your image more interesting.

don't go through life with a flashlight shining directly at the middle of our faces, after all. The flash stick solves this issue in a magnificent way. Moving the flash off the camera allows us to create shape- and texture-defining shadows. Adding a modifier to your flash allows you to further refine the look of the shadows your flash produces.

45

FILL-FLASH EXERCISE

et's try another exercise. We'll start with something simple: basic fill flash. Call upon a human subject who loves you very much and ask them to sit quietly in a shadow. This shadow should be surrounded by both bright and dark areas.

Begin by dialing in the desired contrast, saturation, and white balance settings on your camera. Choose a lens and a spot fairly close to your subject—say, 6 to 10 feet away, depending on the length of your flash stick. Pick a middle-of-the-road aperture, somewhere between f/5.6 and f/11. Finally, frame your subject and choose a shutter speed that makes the bright background look wonderful.

Your first picture should show a wonderfully lit background, but your subject should be in heavy shadow. (If not, then make it happen.) From this point, adding fill flash is a breeze. Just take a guess

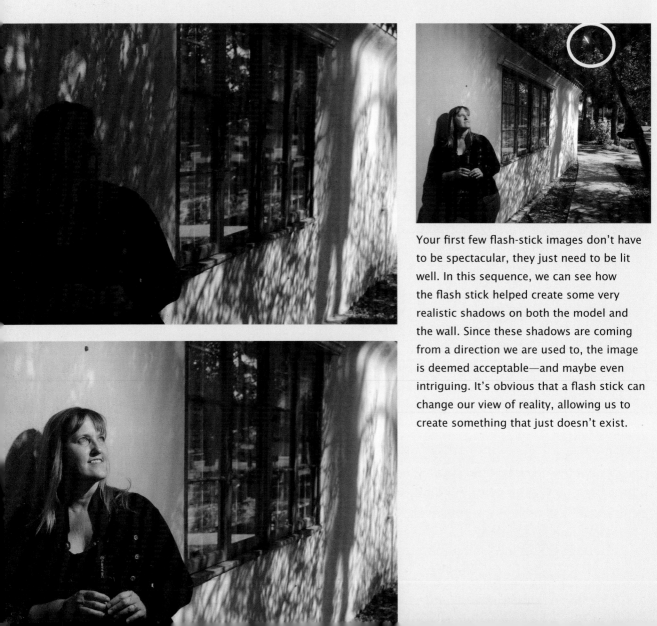

Your first few flash-stick images don't have to be spectacular, they just need to be lit well. In this sequence, we can see how the flash stick helped create some very realistic shadows on both the model and the wall. Since these shadows are coming from a direction we are used to, the image is deemed acceptable—and maybe even intriguing. It's obvious that a flash stick can change our view of reality, allowing us to create something that just doesn't exist.

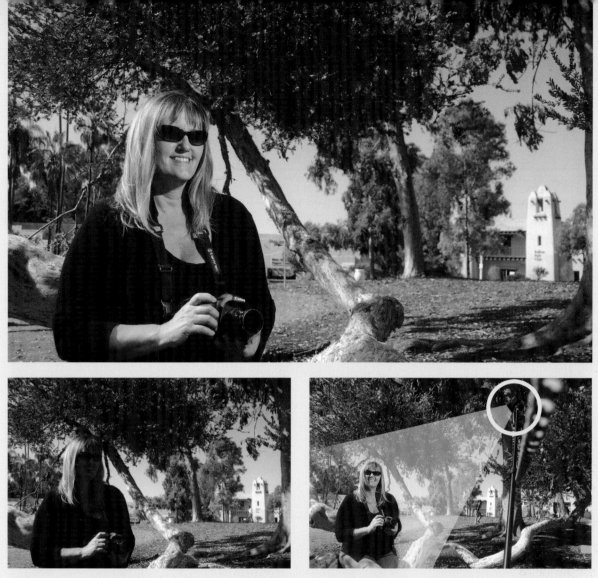

With the flash pushed back slightly, we were able to add enough light to cover her from head to toe. For less coverage, we could have moved the flash in closer, adjusted the flash's zoom setting, or modified the flash with a snoot. Notice the natural-looking shadows; an on-camera flash would have flatly illuminated our subject.

(that's right, guess) at the power setting needed on the flash. With all the experience you've garnered from the previous exercises, this should be no problem. Reaching out with your flash, extend the flash stick and put it directly across from your subject, aiming it at their head. Fire.

Now, simply check your image and make any needed adjustments to the power settings, angles of coverage, or contrast and saturation. Voilà! Your first in-the-field, flash-stick image is done.

FLASH SYNC

If you're using an inexpensive wireless transmitter or your camera/flash combination that doesn't offer high-speed flash sync, you must remain below your camera's flash sync speed (check the camera's manual). If the image is too bright at this shutter speed, choose a smaller aperture or lower ISO. You can also add a neutral density filter or variable neutral density filter (fader) to remove excess light.

FILL-FLASH EXERCISE 2

For fill flash, not much can beat the flash stick. When it comes to pure creation, nothing even comes close. Let's try another experiment. Grab your model and ask her to simply sit in front of you outside. Ensure she is not hidden in any shadow. Begin by shooting a photograph of your model in light that has her exposed perfectly. Don't use the flash. This shouldn't be too difficult.

Now, let's play. Adjust either the aperture, the shutter speed, or the ISO to take away light. Make the entire image somewhat darker. (You already know you can make the background black, so let's stay away from that extreme; just dial-in a slightly darker than usual background.) This is the moody background from which your subject will shine forth, so really go for it.

Grab your fully extended flash stick, aim it at your subject, and fire. Check your image, make any adjustments needed, then fire again. Don't stop until you have your subject lit perfectly and jumping out from a very dramatic background—even though there wasn't one there to begin with.

Creating mood is just a flash stick away. The image below shows a darkened background (and, so far, a darkened subject, too). The photographer simply dialed in the settings required to produce a background that was darker than it appeared in real life. On the facing page (top), you can how the subject pops from that dark and brooding background when a flash stick is employed. The bottom image (facing page) shows the setup.

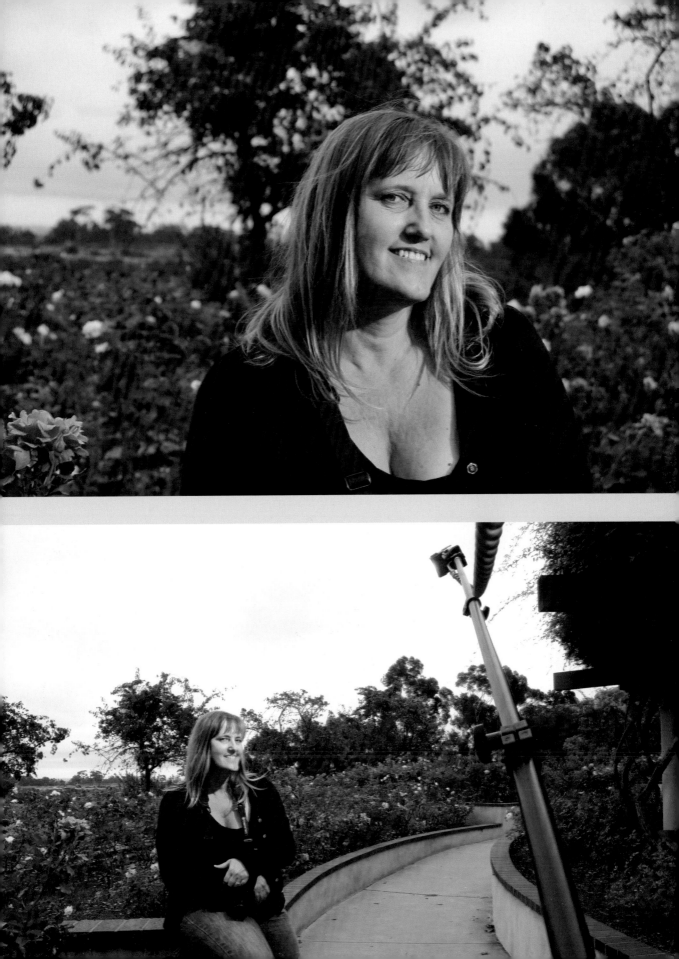

ADD A POLARIZER

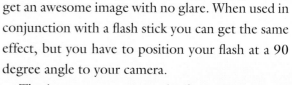

You can expect even more dramatic results the instant you begin using a polarizing filter to cut glare in your flash-stick creations. Flash creates a lot of glare, so if you intend to use flash, you should use a polarizer as well.

The polarizer is an easy tool; simply turn it until it eliminates the glare. In non-flash photography this is easy. Set yourself up at 90 degrees from the light source creating the glare, turn the polarizer until you see the glare disappear and—poof!—you get an awesome image with no glare. When used in conjunction with a flash stick you can get the same effect, but you have to position your flash at a 90 degree angle to your camera.

The image sequence on the facing page shows the stages of message-building when a subject is in bright light. The first shows how the bright scene appeared. The model is properly exposed, but the background is very bright.

In the second image, a faster shutter speed was dialed in to help with the background. However,

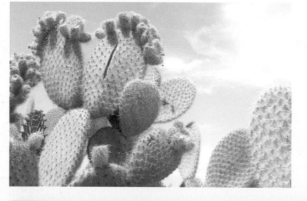

It's not about shooting what's in front of you and making it look "pretty" after the fact; it's about creating a spectacular image right in the camera. Say goodbye to Adobe Photoshop, gang! We can easily stretch out the flash and add light to the subject. With the flash here at a 90 degree angle from the shooter, a simple turn of the polarizer eliminated any glare his flash produced, resulting in the image seen below.

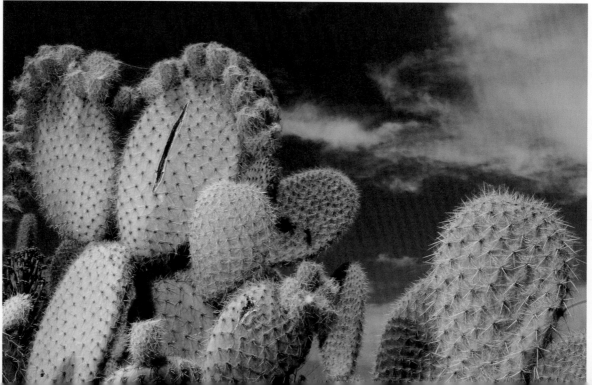

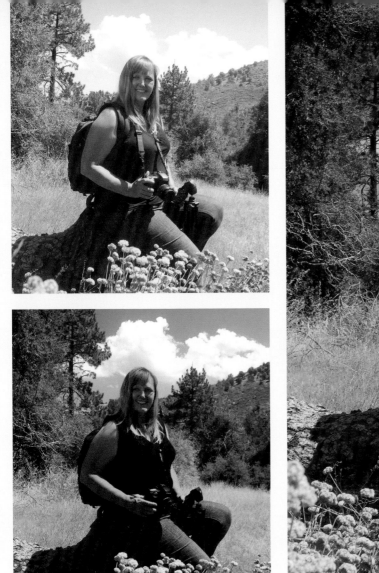

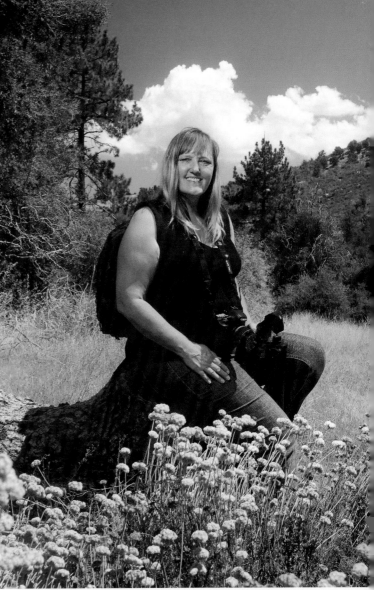

TOP LEFT—How the scene actually appeared to the eye. BOTTOM LEFT—The effect of adding a polarizer. RIGHT—The final image with the addition of light from a flash stick.

TUNE OUT GLARE

Here's a quick reference shot to show the immediate glare-cutting effect of a polarizer placed at the correct angle.

since the faster shutter speed took light away from the entire image, the model fell into darkness. You can also see the effect of glare on both the model and the background.

The third image shows what happened when a polarizer was added to eliminate glare on both the background and the subject.

At this point, it's obvious: we needed to add light to the subject, so a flash stick was added to balance the light on the background and subject.

POLARIZERS IN PORTRAITS

There are some things even the best computer program or advanced camera settings can't fix: one is poor composition, the other is glare.

As noted in the previous section, if you use a flash, you are creating glare. And despite what you may have heard, umbrellas and softboxes do not eliminate glare, they only weaken it. So what does this really mean for your images? In the sequence on the facing page, take a look at the model's skin tones. Even with an umbrella modifying the flash, there's a dramatic improvement from the top image to the bottom image (in which a polarizer was properly implemented). If you want to shoot with clean light—if you want the best photos you have ever shot—then you have to use a polarizer and you have to use it the right way.

Using a polarizer to eliminate glare from a flash can be challenging since you will not be able to see the effect in the viewfinder. To achieve maximum glare removal, the polarizer *must* be turned correctly. Just having it on your lens will not work. Luckily, on many polarizers there are marks (small grooves, painted marks, or small dots) indicating how to turn the polarizer. Simply point this mark at your light source to eliminate unwanted glare. However, some polarizers have no marks at all and some work on the opposite side of the marks. You'll need to take some practice shots using your flash to find the "sweet spot" on your polarizer. We suggest using a silver permanent marker to place personalized marks on the outside ring of your polarizer once that perfect location is found.

RHYTHM, LIGHT

Great photographers see the things around them as graphic elements. Here, the vertical rhythm of the trees gives the viewer a direction to follow. The photographer silhouetted the trees using a fast shutter speed and small aperture. Next came a bump of contrast and saturation. He then added some light from a flash stick high and to the left. A quick turn of the polarizer stripped the glare.

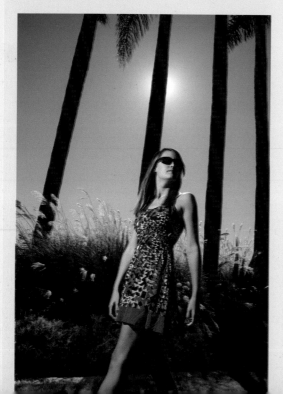

FACING PAGE—Here we see the dramatic effects of adding a polarizer. In the top image, you can see just how much glare appears on the model's face—even though a diffused, reflective umbrella was used. For the botton image, a polarizer was added in the correct position to cut the glare. Notice how much better her skin tones look in this image. A big improvement!

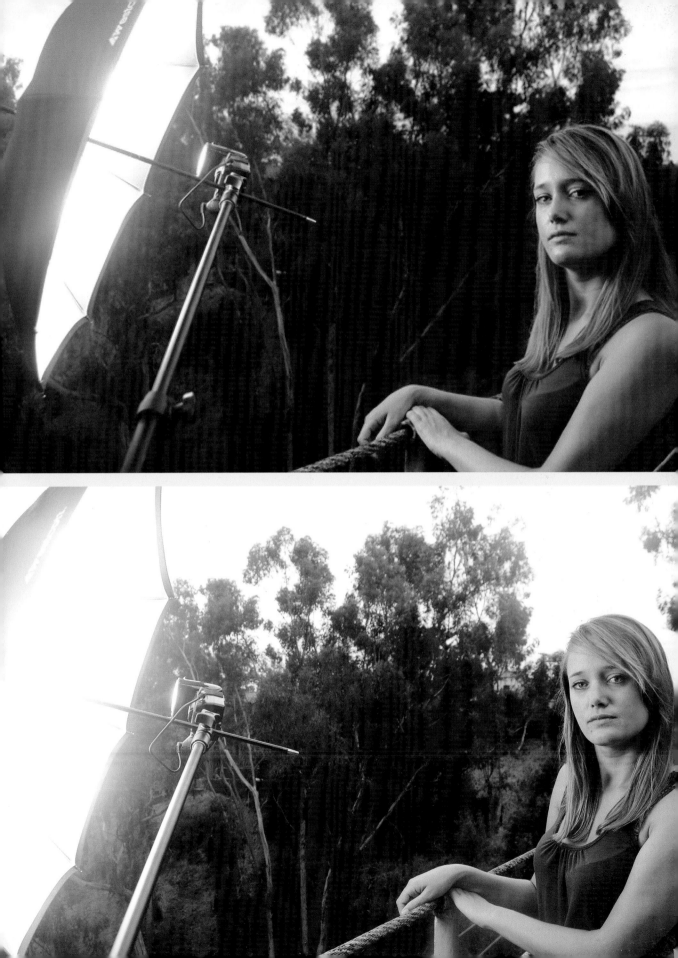

POLARIZED SKIES

A flash stick offers a world of lighting options, even when the world itself doesn't present obvious ones. For the series of images on the facing page, our subject was in bright light—but that didn't mean the image couldn't do with more.

Once we dialed-in the perfect background, our subject fell into darkness. Therefore, we *had* to add light to this image to keep the subject.

The key to the success of the image on the facing page was the use of a polarizing filter to make the sky extremely dramatic. Notice the low angle of the photographer. This was the only spot where the amazing, rich blue sky was possible with the polarizer. Since the polarizer can do its job only when it's placed at a 90 degree angle to the light source creating the glare, the photographer had no choice but to shoot from this perspective.

TOP LEFT—The world according to auto. The camera's chosen aperture, shutter speed, and ISO settings exposed the background well but left our subject in the dark. **TOP RIGHT**—Adding fill flash balanced out the exposure. However, there's an even better option. **BOTTOM LEFT**—Dialing in our own camera settings and adding a polarizer made a dramatic difference to the overall richness of the picture. **BOTTOM RIGHT**—Adding a dash of light from a flash stick resulted in instant awesomeness!

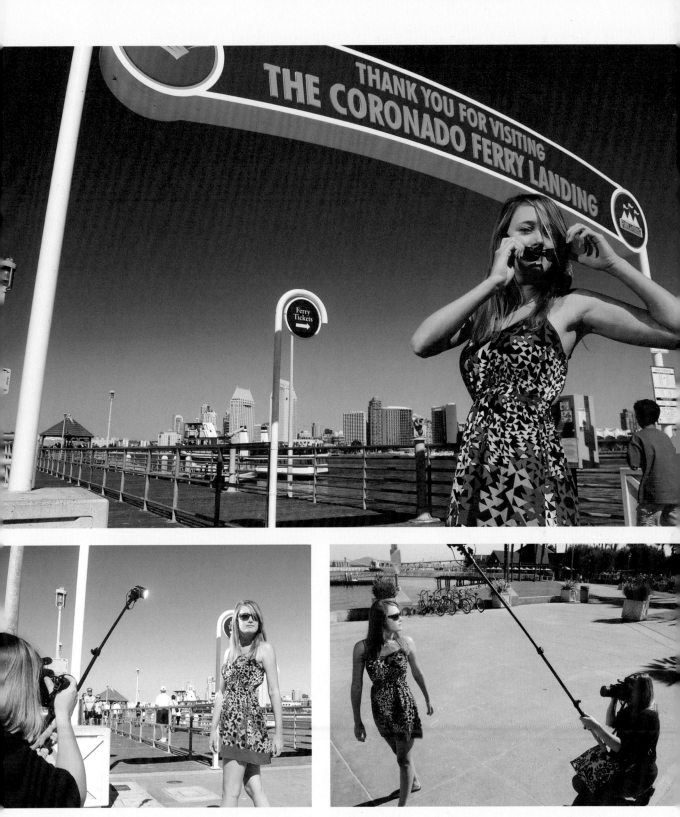

Adding a polarizing filter was the key to boosting the drama in this image (compare the unfiltered sky in the bottom-left photo to the polarized sky in the top image). The photographer had to shoot from an unusual angle to get the full polarization effect.

Mental Gymnastics

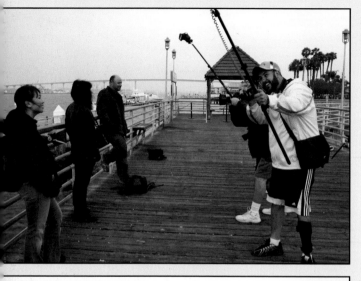

It can get tough, juggling all this information in your head. The first time you use your flash stick, it will seem like a nightmare.

If it makes it easier, think of this as a multiple exposure "event" (even though, technically, it's not a multiple exposure at all). You are responsible for two exposure levels: the amount of ambient light your camera captures (that would be the part of the picture that the flash doesn't touch) and what your flash lights up (that would be the second "part" of this pretend multiple exposure).

To control the amount of the ambient light, you adjust the aperture, shutter speed, and ISO on your camera. To control the other flash, you adjust the power setting on the flash unit—or its distance to the subject.

Which of the two light sources you choose to deal with first is your choice as an artist. To us, it's easier to start with the background and work our way forward—but you can do it the opposite way if it makes more sense to you.

Working with a flash stick is not as difficult as it may seem. Sure, you've got to juggle a few pieces of equipment, but the results are very much worth the effort. In this series of images you see some dedicated flash students pushing their vision—and their flashes—to the limit.

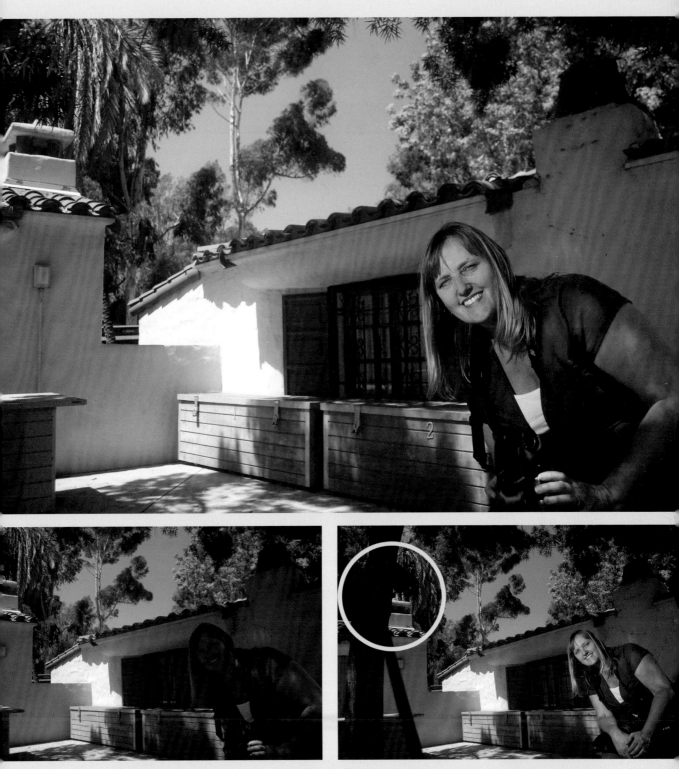

We could have compromised and let the background get brighter to get the right exposure on the subject, but that would have changed our initial vision. With a flash stick, your vision will always remain free and your heart can explore. Note how controlled the lighting is; we were able to illuminate *only* our model.

About the Background

If you recall our message-building approach, we suggest choosing your aperture (for depth of field), then selecting a shutter speed to capture the desired amount of light. In the case of a flash-stick image, that "desired amount of light" would be on your background. After all, no man-made flash attached to the end of stick is going to light that.

This is where experience with manual camera control will come in handy. The more quickly you can set the background exposure with your

aperture, shutter speed, and ISO, the better you'll be with a flash stick. In auto mode, you can't create anything dramatic because your camera is always trying to make a "normal" photograph.

Start by picturing what the best background would be—how it should be lit and what the contrast and saturation should be. Really think about it. Change the in-camera settings, then shoot it. Don't even bother with the flash stick yet. Get your background down first.

Think about making the background darker than it is. Push your vision, explore your heart. Then add blur to the equation. Think about using larger apertures. Consider focusing closer to you or using longer focal lengths. Explore what you can do with a background. Gain the experience you need to become a true artist—to change what you see to match what you imagine. Be more than "just another photographer"; the world is already full of *them*.

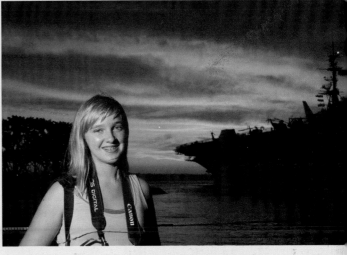

TOP RIGHT—Once the background was dialed-in, it was obvious our subject needed some help. BOTTOM RIGHT—A flash stick was employed to add the necessary illumination. LEFT—To achieve the different color we changed the camera's white balance from 5200K to 2500K. This added the blue tone. To balance the color on the subject, we added an amber gel to the flash.

THE SPIN EXPERIMENT

Head outside on a very bright day along with a willing model. Find a location for your model that's hidden in dark shade—but make sure there is plenty of bright light and exciting coloration behind them. Place your model in the deepest, darkest part of that shadow, making sure it engulfs them completely.

Then, dial in an aggressive contrast and saturation setting (really crank things up). Choose a white balance that gives you the best-possible color. Set your shutter speed to $^1/_{40}$ second and turn your ISO to 200. You'll now need to find the aperture size required to make your background lit perfectly. Keep in mind that your subject will fall into darkness (this is part of the exercise).

Once you've got your background lit well and your subject in the dark, add light with your flash stick. Simply place it high and to the left or right of your subject and fire. Then, examine the image and make any needed corrections to the power of the flash and fire again. Keep adjusting your flash setting until your subject is lit perfectly.

One of the most powerful advantages of the flash stick should now be in full focus. Even though you're using a very small aperture, the actual power output of the flash can be kept to a lower setting. This is because the flash is so close to your subject. This then saves batteries, offers you creative shadow-building options, and allows you to use whatever apertures you like.

Experiment with the position of the flash, moving from the right and left side of your model, creating various shadows. Bring it in closer to your subject to see the gain of light and pull it farther away to lose light.

Once you've got the perfect image, take one more—but this time, spin the camera while you take the photograph. Hold the camera tightly in

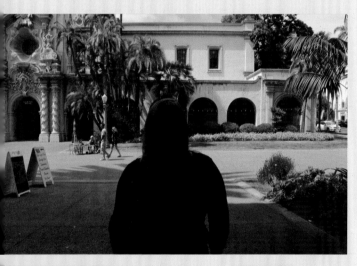

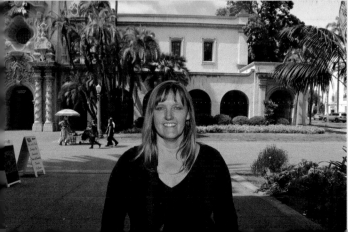

TOP—The exposure was dialed in for the background. A shutter speed of $^1/_{40}$ second was chosen, and an aperture of f/13 was used. The background is nicely exposed, but our subject is buried deep in shadow.

BOTTOM—Flash was added on our subject for an exposure that balances the ambient light (background) and the light created by the flash (subject).

The ambient and flash exposures do not relate to each other and can be (in a way) considered completely separate events. To prove this, we spun the camera during this exposure. The long exposure time of $^1/_{40}$ second shows movement in the areas lit by ambient light, so we see a wonderful spin of color emerge. The flash, however, happens in an instant, so it hit our model and froze her solid. It's almost as though we captured two separate moments in time—one lit by ambient light, one lit with flash.

your right hand and rotate it clockwise or counter-clockwise (whichever is more comfortable) as you shoot. You must press the shutter in the middle of the spin to get the full effect. The more fluid your spin, the better your photo will be.

What you'll see now is that perfectly exposed background spinning in a circle. This is because the slow shutter speeds captured motion blur from the ambient light. However, the flash burst is so fast that it's not affected by the longer shutter speed, so you'll see that the model is frozen solid.

This experiment reinforces the fact that, when combining flash and ambient light, you are essentially capturing two instances of time in one image. The first instance is the ambient-lit background. Its exposure is controlled by the aperture, the ISO, and the shutter speed. This, though, has *nothing* to do with your model. The illumination falling there came solely from the flash. Because that burst of light lasted only microseconds, the shutter speed had no effect on it. It could not be blurred by the movement of the camera because the shutter speed had nothing to do with its level of illumination to begin with.

TOTAL CONTROL

When you start thinking of your flash-stick images as being, essentially, two images in one, you'll be well on your way to successful flash photography—even without your flash on a stick. You have to take some responsibility and make some important decisions. How do you want the background lit? How do you want the subjects illuminated? When using a flash, you are not just taking pictures, you are creating your own reality—the flash stick simply gives you more options. As the photos in this section show, those options are limited only by your imagination. You can choose to light only what you want for a dramatic look. You can choose to subtly add light where it's needed, for an image that looks very natural. You can add a bold splash of light for a spotlight effect or opt for a subtle wash of light that just opens up the shadows. As an artist, it's up to you to take total control of your images.

Here, you can easily see the value of a flash stick. These images were shot under midday sun. The photographer simply chose a shutter speed, aperture, and ISO setting that made the background darker than it actually appeared. He then added light with the flash stick. Since the stick enabled him to move the flash far from his body, he was able to isolate just one person from the group. The flash stick was held high and to the left in both images.

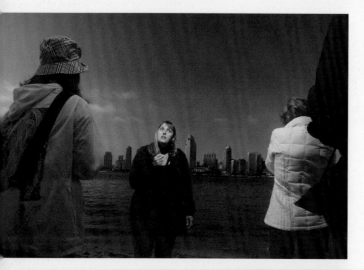

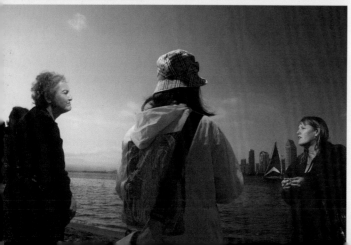

WHAT WOULD YOU DO?

Think for a moment what would happen if you were in total control of light—if you could, at any point, aim a spotlight at anything you wish, making it as bright as you would like. Now, imagine that you have absolute power over the lighting of everything else. On a whim, you could make things as bright or dark as you want. What would you do? What would you create? Would you create something that defies reality, setting yourself and your images apart from the average world? Or would you take "just another picture," lit the way it "should" be, the way it's expected? Challenge expectations and be the artist who creates!

With just one flash stick, your lighting options change dramatically. No more settling for what mother nature provides, no more compromising. In the bottom-right image, you'll notice that the flash is modified with a LumiQuest Big Bounce. This is one our favorite modification tools. It's smaller than an umbrella, yet it still produces an amazingly large area of usable light—as the top-right image shows.

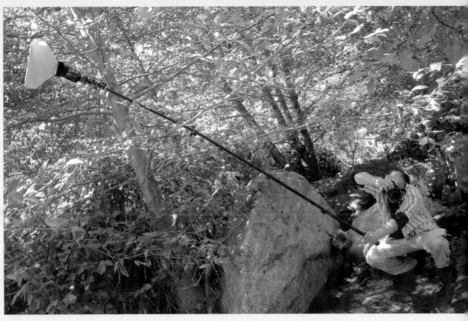

Make It "Pop"

Dynamic angles require dramatic settings and lighting. We're often asked how to get that certain "pop" to come from an image. The only way to answer that is to bring the conversation back to feeling. If you're looking to be more "aggressive" with your image—if you want the intensity of your photographs to smack the viewer right in the face—then simply be more aggressive with your approach. Look for lines, shapes, and patterns, then turn them on end. Set the contrast,

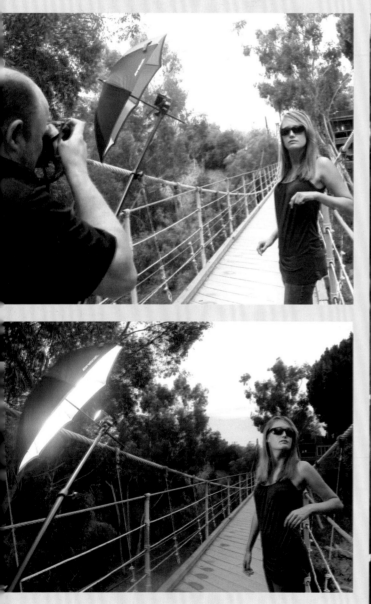

saturation, white balance, and sharpness unusually high. Aim leading lines in your scene right at your subject. Then add some dramatic lighting. It's usually a combination of things that give a strong image that "pop."

Even though the image below appears to have no light added whatsoever, there is a ton coming out of the reflective umbrella; but it's not just the light that makes this image work, it's everything else. Every tiny detail was visualized before the image was shot—the composition, the feeling, the angle of the light, the pose of the model. Every choice was made for a reason. As the bottom-left image shows (facing page) the scene in real life looked nothing like what was captured.

The composition, pose, and lighting are all working together to give this image its impact.

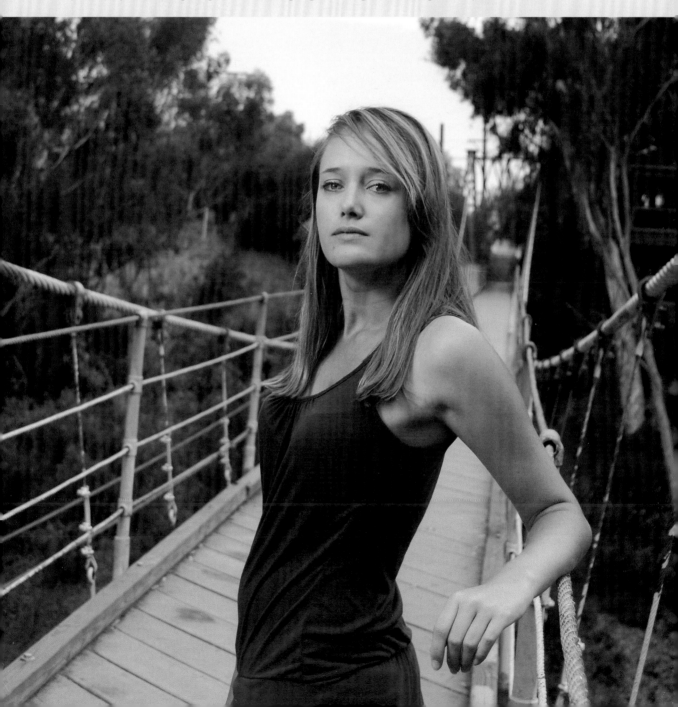

AMAZING COLOR

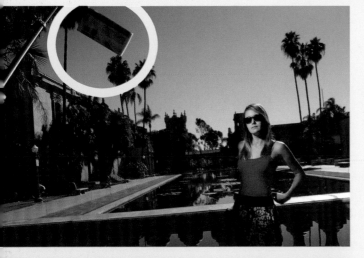

The is nothing wrong with asking your model to participate in the creation of these eye-popping images through more than just her pose—ask her to select clothes that will complement the scene. For the images seen here, we anticipated creating a dark, rich blue color in the sky by underexposing, so we had the model wear red, a complementary color. Nothing says "look at me!" more than the contrast between the two extreme opposite colors. It's a real attention grabber.

LEFT—To snoot the flash, narrowing the angle of the light that is produced, we used a simple oatmeal canister over the flash. This is an inexpensive approach, but it's highly effective.

FACING PAGE—Once balanced, the flash stick feels like part of your arm. There is no feeling like it, especially since it gives you the power to turn a normal scene into a spectacular image.

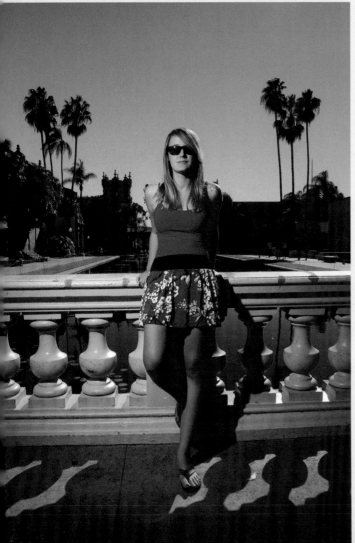

COLOR WHEEL

Tones opposite each other on the color wheel provide contrast that can make your images more eye-catching.

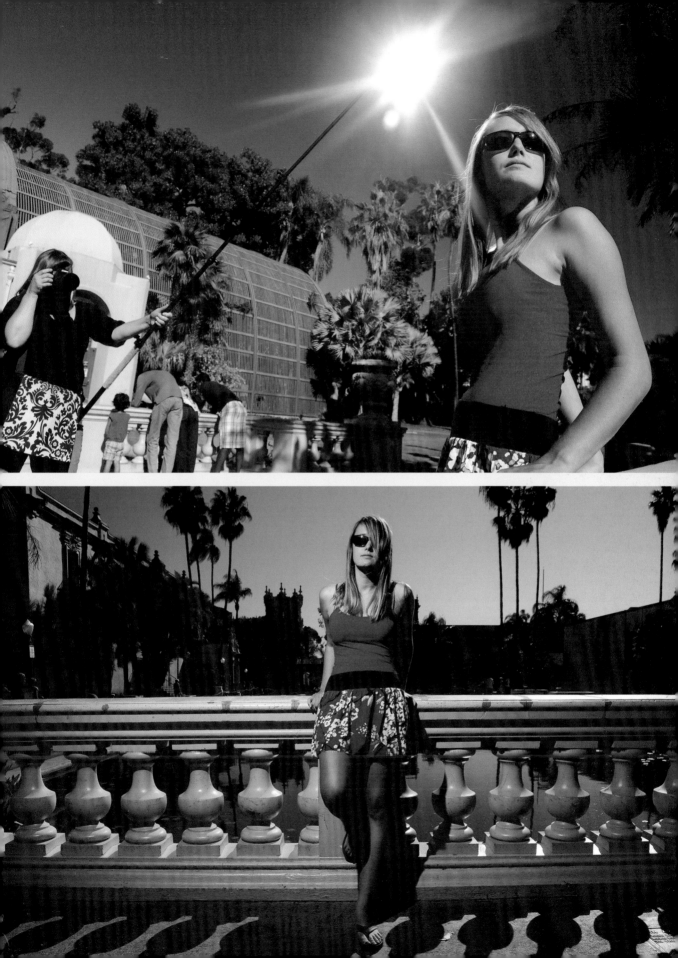

Macro and Close-up

Macro and close-up photography have intrigued photographers since the dawn of the camera, but it wasn't until the birth of the flash that we could capture this tiny world in all of its in-focus glory. With a flash, the gloves were off and the need for a tripod disappeared. No longer did we have to shoot only motionless subjects (or subjects we immobilized). We could shoot anything, no matter what action was going on. Movement from wind and rain ceased to be a threat as well. Along with the extra light from the flash came faster shutter speeds and deeper depths of field. The flash alone is awesome for macro and close-up photography—and the addition of the flash stick further enhances our abilities.

When it comes to using a flash stick in macro or close-up photography, it's all about reach and creativity—one feeds off the other. The farther you can push your flash away from your camera, the farther your vision can go.

A flash stick releases the macro and close-up photographer from the restrictive grip of natural light. It allows his vision to soar and his images to remain sharply in focus. Here, a small aperture, fast shutter speed, and low ISO created the moody background you see (even though it was noon and the sun was blazing). The flash stick offered the photographer a choice about where his light would fall. The higher angle he chose here created the dramatic shadows. An on-camera flash approach would have fallen short.

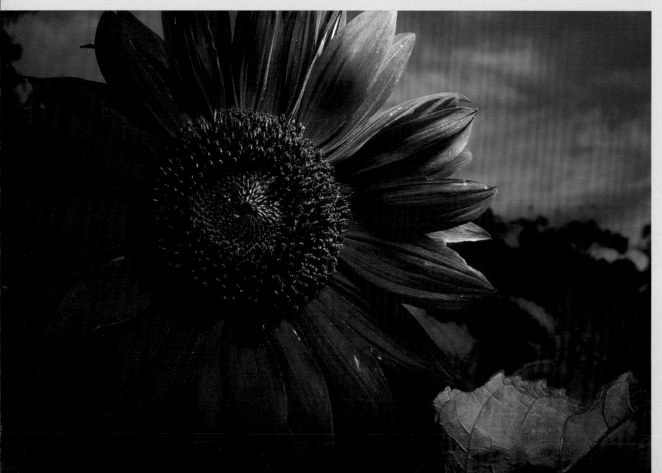

ABOVE—The flash stick offers a unique perspective on the world, no matter how small that world might be. The surreal quality that comes from the extreme sidelighting in this image would be impossible with an on-camera approach.

RIGHT—With a flash stick, your options are multiplied. Not only can you light a simple, close-up subject beautifully, but you can also light what's *behind* it. In this image, the flash stick was pushed farther away, allowing the light to spread out and include not just the subject but also its surroundings.

MORE REACH MEANS MORE OPTIONS

If you're stuck with your flash on-camera, the real creative process can't even start. Sure, you can light your subject well—but only if that subject is right in front of you. When shooting close-ups, there are often other elements of the scene between you and your subject. If you use your on-camera flash, the light hits these elements first and they end up being lit much more brightly than you'd want them to be. Off-camera flash is a necessity when creating magnificent close-up images; the stick gives you even more reach and even more options for lighting around these elements.

GETTING IT DONE

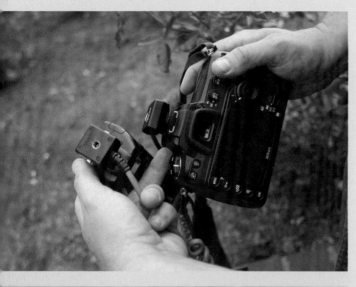

Creating an amazing macro or close-up image with your flash stick uses exactly the same techniques you've already learned. Start with a vision, dial-in the perfect background, then add flash to taste.

LENS SELECTION

You'll want a lens that can get close, but (and this is the best part of using a flash stick) it doesn't have to be a macro or close-up lens! Long lenses and inexpensive zoom lenses work great with the flash stick; the distance and the awe-inspiring motion-stopping power of the flash go hand in hand.

CAMERA SHAKE IS NOT AN ISSUE

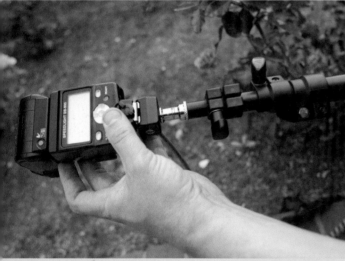

Especially with a long lens, this will feel pretty awkward at first (we admit it)—but you don't need to worry about camera shake too much. If you choose a small enough aperture, fast enough shutter speed, and low enough ISO, then your flash will be the only thing lighting your subject. If that's the case, being a little "awkward" with your camera gear won't be an issue. Nothing can be blurry.

When shooting close-up images, we like to use a simple TTL sync cord. Once the cord is connected to the camera and flash (top), you simply attach the cord itself to your flash stick (middle) and you're ready to go. The corded option maintains your gear's high-speed sync option (if you have it). This comes in handy when you want to create black backgrounds with faster shutter speeds and larger apertures (as seen in the image on the facing page).

The flash stick gives you plenty of reach when shooting close-up images (even when you're not "close up"). If you run across a bug or something that doesn't like to have its picture taken (or maybe something you're allergic to), this is your answer. Just use a longer lens, dial in a very small aperture (for increased depth of field), extend that flash stick, zoom in all the way, focus, and fire away. Can life get any sweeter?

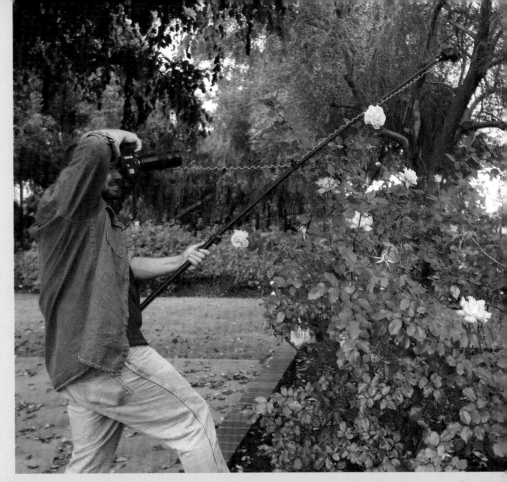

SHORT-STICKING

While the power of the flash stick is usually best seen when pushed far away, there are instances (such as when creating macro and extreme close-up images) when you'll want to employ a short stick—a technique we have aptly named "short-sticking." If you keep the flash close to you when you shoot, then you'll have plenty of flash coverage options when dealing with extreme images.

We've successfully used a collapsible tripod (the Tamrac Zipshot) as a short light stick. It not only folds easily into a camera bag, but it can also be used as a tripod. There are also light stand "extenders" that can be used as short flash sticks.

There is an important difference between short-sticking and normal flash-stick usage: you will usually lose the ability to brace the bottom of the stick on your hip or thigh. With a short stick, all the weight of the flash and stick will have to be held by one hand. This will restrict the amount of extra gear (modifiers, additional flashes, etc.) you'll be able to employ.

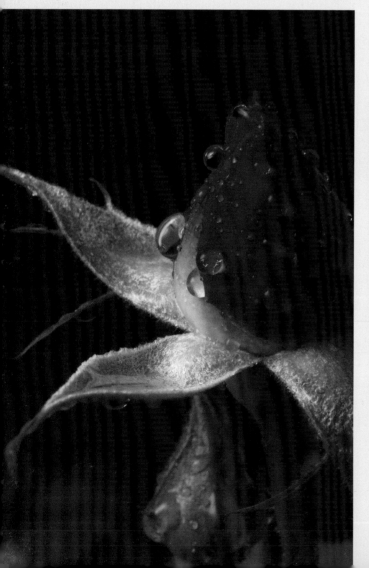

The short-sticking technique works amazingly well when using a macro lens and a flash modifier.

Even when short-sticking the flash, it's important to remember that you are creating a dramatic image and not just shooting an ordinary picture. The top photo illustrates the vision we were pursuing, while the bottom-left image illustrates how the scene actually appeared to the naked eye. To get the desired image, we simply rotated the polarizer and chose a faster shutter speed (to make the image darker than the scene appeared in reality). We also adjusted the in-camera contrast, saturation, and white balance settings to taste. Finally, we aimed the flash stick at what we wanted brighter and fired.

73

DOUBLE UP THE FLASH

The two flash sticks are connected to one another by a simple light stand bracket. One stick rests comfortably on the shooter's leg, while the other stick is placed under the arm to help steady the device, providing perfect stabilization.

WELCOME TO THE GUN SHOW

As any flash photographer knows, sometimes one flash just isn't enough. The beauty of the flash stick is that it affords the creative photographer the chance to really step outside of the box and add as many flashes as he wants (or at least as many as he can carry).

Again, the flash stick is designed as a lever, so the extra weight of a few flashes and modification devices shouldn't be a big issue.

However, if you're looking to stretch the flashes apart from one another (an important thing in many situations) then you have to get a bit more creative with your approach. In this case, we like to connect two flash sticks to each other using a simple light stand bracket (as seen in the photo to the left).

A double-barreled approach can be seen in this image. The upper flash is providing some amazing top lighting, while the lower flash is illuminating the subject's face.

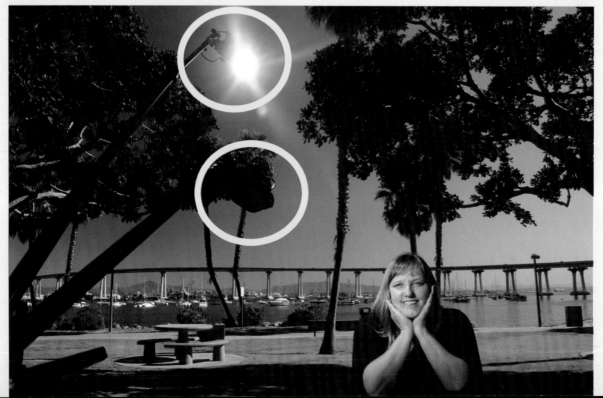

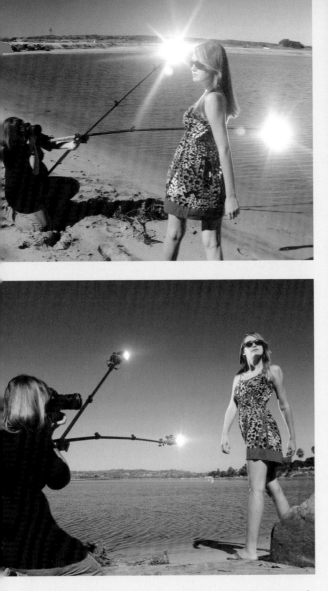

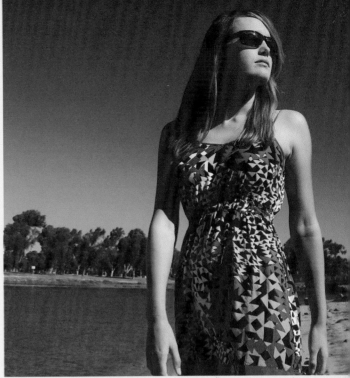

In this series, you can see two flash sticks being used by a single, unassisted photographer. The results of this approach are quite fantastic. One flash is used for backlighting, filling in the far edges of the subject, while the other adds light from the side. Both flashes are as close to 90 degrees from the shooter as possible. This enables the polarizer to work at 100 percent efficiency. The images on the right show the effect of full elimination of glare. Compare the before (top right) and after (bottom right) images. You can't make a change like that in a computer program.

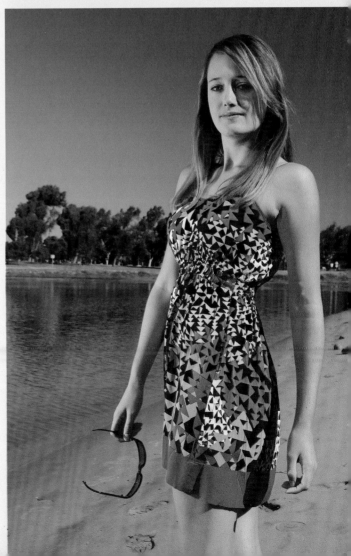

BUILD YOUR PERFECT SHOT

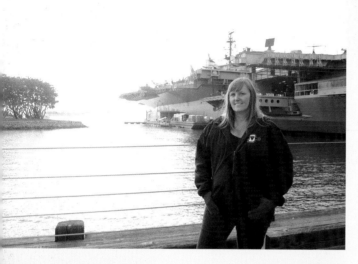

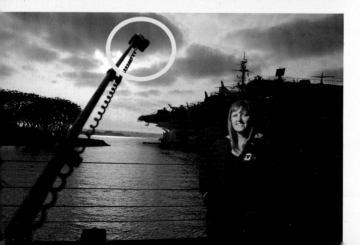

There are so many options when creating with a flash stick that you may never want to stop in your pursuit of the perfect image. Seriously—it's *that* much fun!

With each subtle (and not so subtle) change to the background and subject, more options will present themselves. Do I put the flash here? Shoot it from this angle? Enlarge it or narrow it? Do I angle myself to use the polarizer for the sky or for the flash—or not at all? Do I look for rhythm or use lines? How dark is *dark* when it comes to a background? Do I make it in focus or blurry? Do I use two flashes or one? Can I light the background with one flash and my subject with the other?

The answer is yes. Do it all! If you've never played like this, you're in for a treat. You're now on the verge of artistic freedom. You recognize the options, now you just need to explore and decide which choices work best for how you feel.

Shoot them all. Don't settle for "good enough" or limit yourself. Push your vision, push your images, and take every one that you can imagine—pushing yourself, one step at a time, toward your perfect shot.

TOP—This is how the scene appeared.

CENTER—A quick change of the shutter speed and aperture took away light from the image, leaving our subject in the dark.

BOTTOM—With the addition of light, our picture became more dramatic. Keep in mind that this decision did come at a price; we can no longer see the detail on the ship in the background.

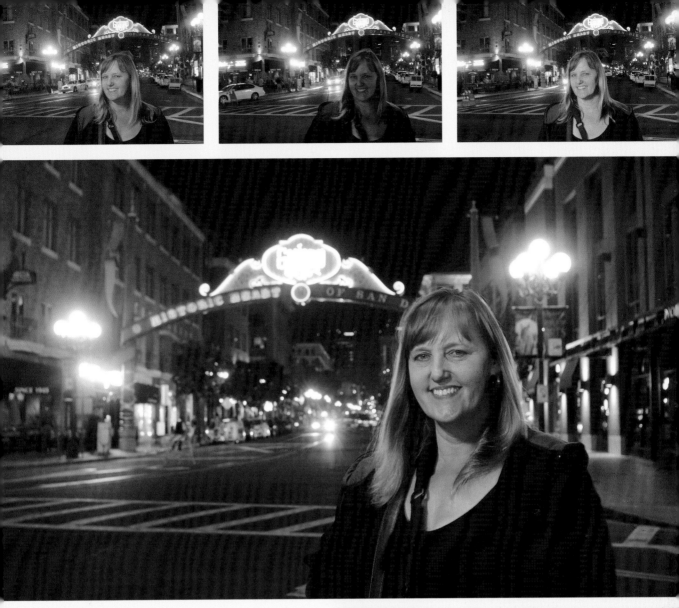

Building a dynamic photograph at night, in the heart of a bustling city, isn't difficult with a flash stick—but you do need to understand the pieces involved. First, you will need to steady the camera and find the right white balance. In the top-left image you can see the effects of a 5200K white-balance setting. The top-center image shows the white balance adjusted to 2500K. Our model, however, is still a bit on the dark side—plus a bit blurry because of the slow shutter speed used. A flash was added in the top-right photo to bring our model up from the darkness and freeze her. Sadly, though, she turned blue due to the 2500K setting. No problem; we simply added an amber gel to the flash for perfect downtown photos!

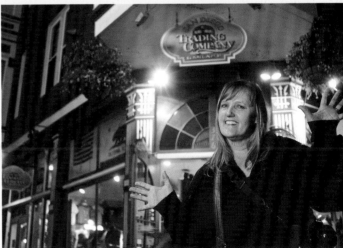

Against a Wall

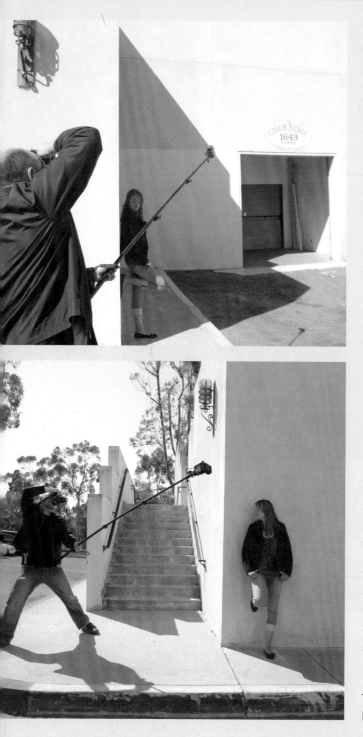

Sometimes it's not so much about the subject as how that subject coordinates with its background. We believe that composition should come first, followed by lighting. If an artist is always creating—using the lines, shapes, patterns, colors, and tones around him for a reason—then his images have to rock. The lighting is the icing on the cake.

The spectacular is always around us; it's there, just daring us to see it. It lies hidden under a mound of biases from which every artist must free himself. Just because something looks one way does not mean that's the only option—especially when you have a flash stick.

Most photographers would never bother creating an image at the location seen here. It just doesn't look that intriguing. But magic can happen everywhere—even if it's beside an old building at the park. The photographer needs to have extreme vision if he expects something extreme to come from his camera.

The contrast, saturation, and white balance you see in the final image were all chosen in-camera to best bring forth the mood and attitude the photographer wanted to capture. However, without adding flash from an extreme angle (made possible by the flash stick), this image would not have been possible. Notice that the flash illuminates nothing but the subject, making her pop out from the surrounding architectural elements for a striking, unexpected composition.

The flash stick allowed the photographer to position his light so it illuminated only the subject.

Studio on a Stick

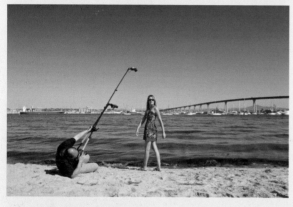

A s a photographer, you should *create*, not just *take*. Rather than simply reacting, try to visualize and achieve. The flash stick offers the you a huge degree of creative freedom. You have, in essence, a complete and mobile studio on a stick— so long as you understand your tool.

Don't forget to challenge yourself. Push your vision and your goals as far as your equipment (and arms) will reach. Ask your models to move far away, then stretch that light out. Add a second flash to your flash stick, then modify each flash as much as you like.

Consider that you are using one of the oldest and greatest tools ever invented: the lever. Take advantage of its power over weight. Stretch your imagination—and light it with your flash stick.

FACING PAGE—Though many may find shooting in the water a bit dangerous, we always follow our heart and vision—no matter where it takes us (or our gear).

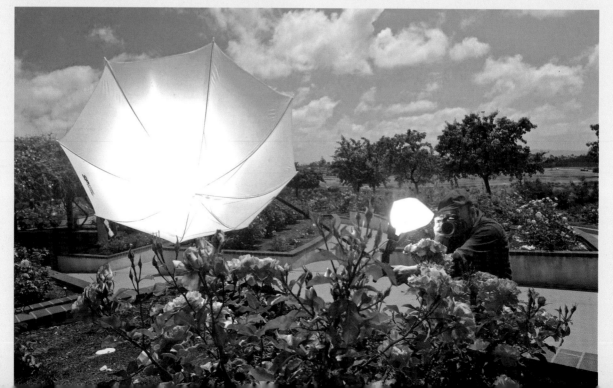

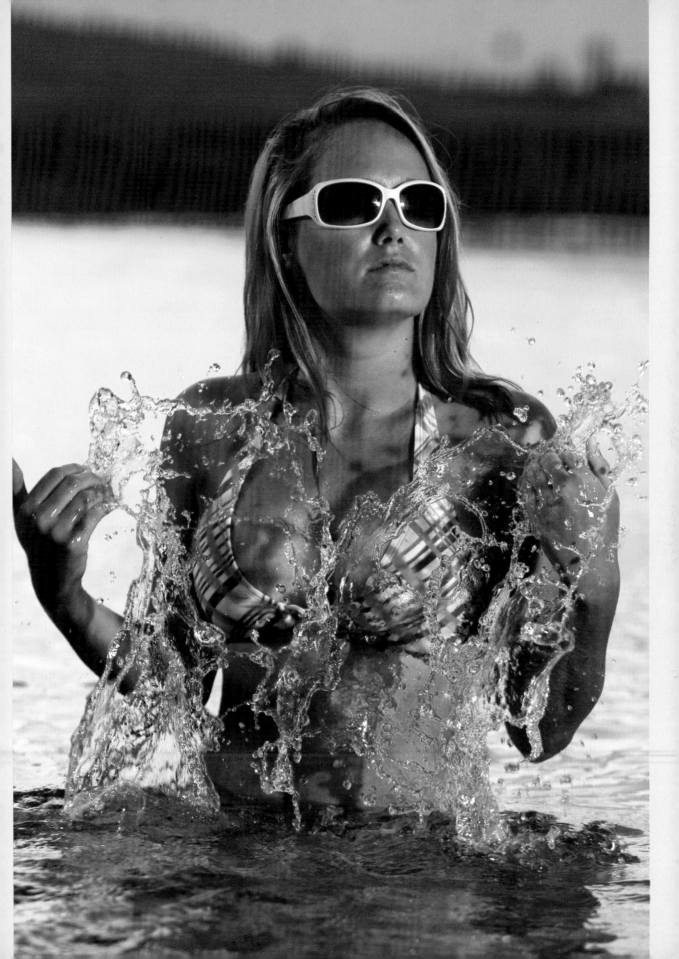

THINK OUTSIDE THE BOX

You might be shocked at where you can employ a fully modified flash stick: in a hallway, in an elevator, near the stairs, etc. The flash stick offers full control and full coverage even in tight spaces, without the fear of overexposing adjacent areas of the scene. Once you've got the basics down, put yourself in some awkward situations and blast that flash. Take advantage of every location and every scene. Learn how to make your flash stick work *everywhere*.

Don't settle for "normal" portraits; push your own vision. Use the flash stick to light up your landscapes in new and inspiring ways. Think about taking an artistic approach to every image. Great photographers often treat the process like painting. They begin with their background and slowly add

Because a flash stick travels easily, it is the ultimate tool for the adventure photographer. You never know where your travels will take you!

light to various graphic elements until they get to the awe-inspiring image they imagined.

No Excuses

It's all about creating spectacular shadows, whether you're shooting portraits or landscapes. Take advantage of the power to add light. Use it to create dynamic shadows, and never settle for anything less than spectacular—even if you're only shooting a tree stump.

Stretch your imagination as far as your flash stick will allow, then push it even further. In the top photo, no one was holding the stick—it was leaning up against the inside of the pillar next to our subject. In the bottom images, you can see how the flash stick created some rather dramatic lighting. Should you choose, you could always add your own human model to the mix in shots like this.

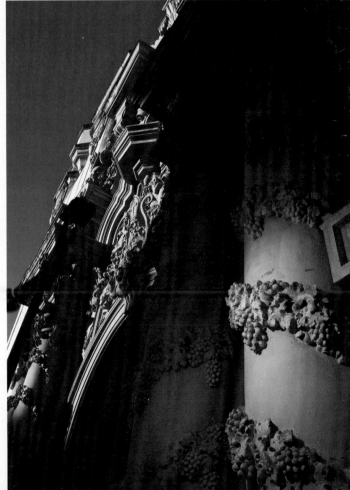

Under Bright Skies

One of the most powerful options you'll gain when you add a flash stick to your arsenal is the ability to keep the background detail in your image—no matter how much natural light might be in your surroundings.

This is of particular benefit when a bright sky is behind your subject (as seen in this image sequence). Without the addition of flash, keeping the subject properly exposed requires an unpleasant compromise: losing all the detail in the sky.

The flash stick helped save the sky in this image sequence. Exposing for the model (top left) blew the sky out completely. However, since we had a flash stick, we could quite easily dial-in our settings for a perfect background and then add light to bring our model up from the shadows.

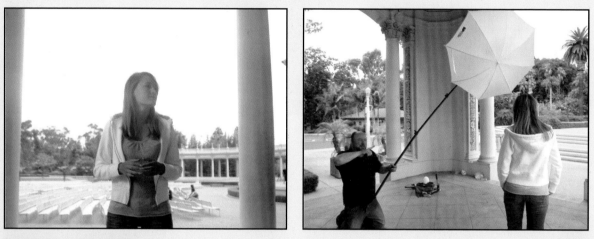

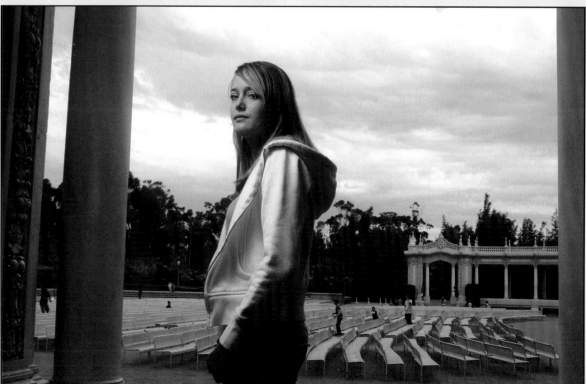

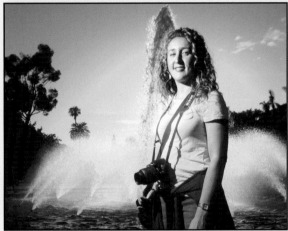
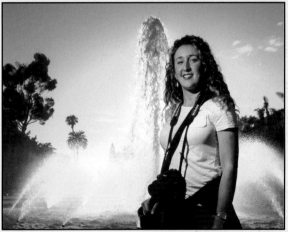

Again, we always recommend you begin the process of creating your image by determining the settings that properly record your background—in this case, the right exposure for the sky. Then work forward to your subject, adding light with your flash stick.

No longer will you have to choose between the right exposure on your subject or the right exposure on your background—you can have them both.

In this series of images you can see the creative process at work. In the top image, we dialed in our background for the desired sky exposure then added light with a flash stick. But this is not the only choice. We could also add blue to the whole image by adjusting the camera's white balance to 2500K (bottom left). Want the subject to return to her "normal" color? Just add amber light back in by placing the appropriate gel on the flash (bottom right). Keep in mind that this modifies your flash output, so you will also have to make the appropriate real or apparent power adjustment to compensate.

AT THE BEACH

This is where you will definitely feel yourself pulling away from other photographers. When you start taking your equipment into the water, be ready for people to be upset. They may even behave as if you're going to throw *their* camera in the water.

We've been shooting at (and in) the ocean, rivers, and lakes for as long as we could hold our cameras. There is just something amazing about using water in your images and surrounding yourself with it. We love to put ourselves (and our gear) out there.

Obviously, this isn't for everyone. If a bit of water and a busted camera or flash frighten you, don't do this. However, if you truly want to push yourself to create amazing images, you have to take amazing risks. (Watch for the big waves though; they'll get you every time.) Shooting in the water is just another option the flash stick affords—and it's one we couldn't imagine being without.

NAIL DOWN YOUR SETTINGS

Do a few test shots before you jump in. You do not want to put your gear at any more risk than necessary by fumbling with settings while you're in the water.

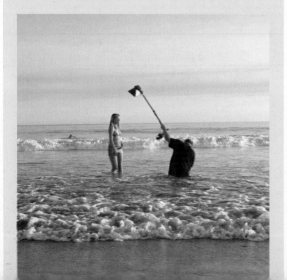

In this series, we can see the dramatic effect of using a flash stick at the beach. We simply dialed in for that amazing sunset and then lit our subject with two flashes (the second one was attached to the lower part of the stick with a clamp). Notice that the top flash was modified with a LumiQuest softbox.

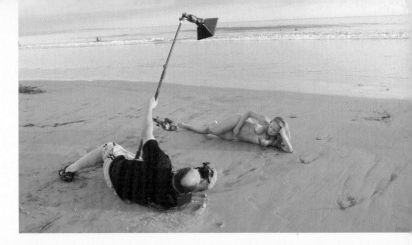

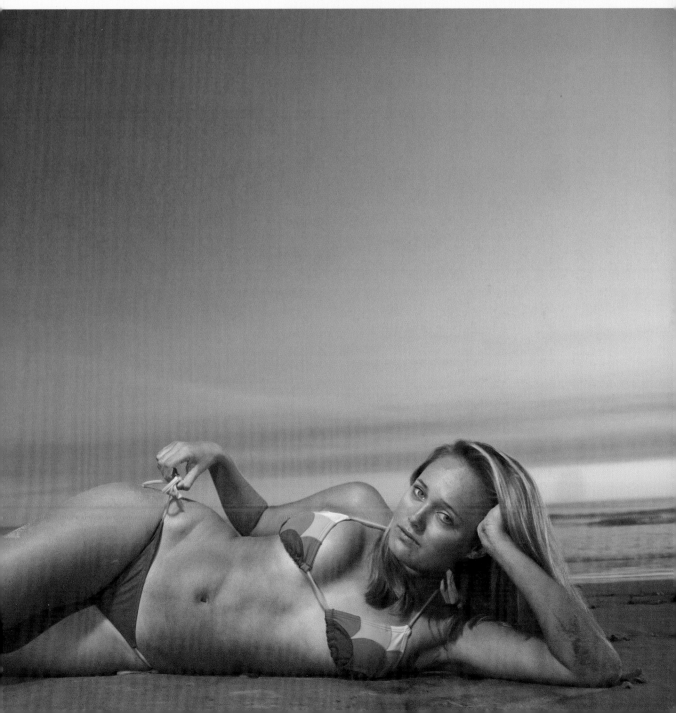

A Few Truths

Here's the truth about using a flash stick: it looks odd. We'll give you that. When using a flash stick, you'll stand out in the crowd. People will take notice—but don't let something as silly as a little embarrassment hold you back, stifle your vision, or kill your creativity. The flash stick is a tool, nothing more. Does it really matter what you look like when using it? If you want the freedom it offers, then you don't have a choice. You've got to get out there and use it. The flash stick gives you extreme alternatives and amazing options—it just lays them there at your feet.

Here's another bit of truth: using a flash stick can be challenging. You don't get all this creative control for nothing. You've got to juggle the camera, the stick, and the flash—an assemblage of gear that very few people on the planet have even put together, let alone shot with as a single unit. There are bound to be challenges when repurposing gear in this way.

There is no automated approach when using the flash stick, and it gets comfortable only with experience. You've got to expect failure at first, and that often doesn't sit well with new photographers. Remember, though, that if something is important, then it's worth investing in it. In this case, the monetary cost is relatively small, but you will need to put in some time and effort. You will need to get

This isn't as much about shooting a "pretty" picture as it is about becoming the artist you know you can be.

In flash-stick photography, the rewards outweigh the challenges.

familiar with the weight of the gear, its nuances, its options, its advantages, and its "issues" before you can expect something magical to happen. That's a lot to ask, we know, but the rewards are definitely worth the fight.

And here's our final flash-stick truth: this is something new; it's a tool in its infancy, so its full potential remains relatively unexplored. We all get to work on figuring it out. The flash stick can stretch your imagination, but only if you let it. You have to *want* to be this creative—to fearlessly explore the unknown. Every year, we teach this technique to hundreds of photographers, and every year they push us further. For every insight we offer, they return with even more ideas and more inspiration. That's the thing about true artists: they share their ideas, inspiring us all and helping everyone to advance.

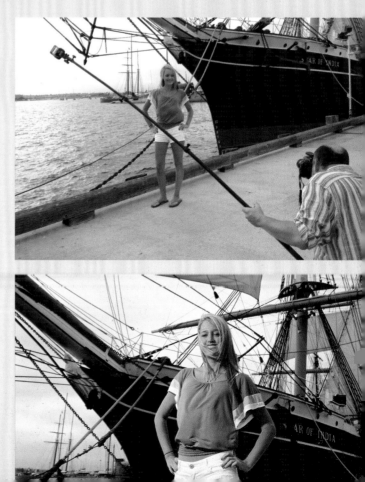

In Conclusion

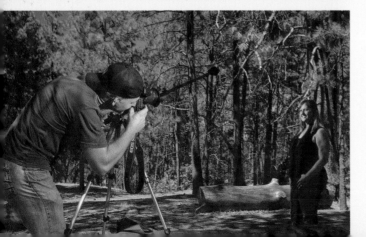

The flash stick can change your photography in an instant. The options it provides are new, and the ease with which it can be used is startling. If you understand your camera, know your flash, and can see beyond what lies in front of you, you can be that artist you have always dreamed of being. No longer will you be delegated to the average or normal. No more will you have to fix your poorly constructed or dimly lit photos in the computer.

A brand-new world awaits. It's time to explore. It's time to visualize. It's time to take that bold step toward real image creation. It's time to use a flash stick.

From our family to yours, we wish you luck with your flash stick. Take what we offer here as simple advice from those who love the art. Use it as a first step to strike forth on your own adventure. Create you own techniques, your own approach. This is what it means to be a real artist. Good shooting!

TOP—Just because it rains is no reason to put your gear away. A rain sleeve for your camera and a Ziploc bag for your flash will get you out and shooting when most go indoors.

CENTER—A drastic change of white balance offers the savvy flash stick photographer a world of options few explore. Just remember to use the "right" colored gel on your flash.

BOTTOM—Make the flash stick part of your everyday shooting, wherever your day takes you. In the mountains, at the beach, in the park—it will always prove a vital and useful tool.

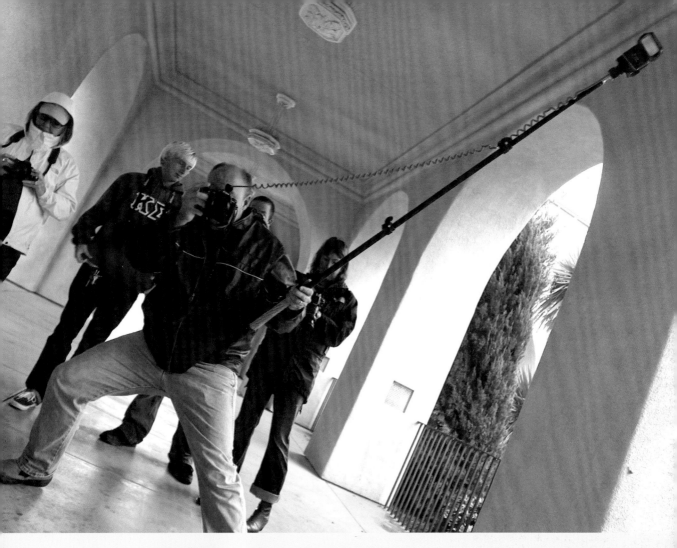

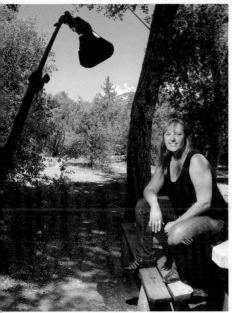

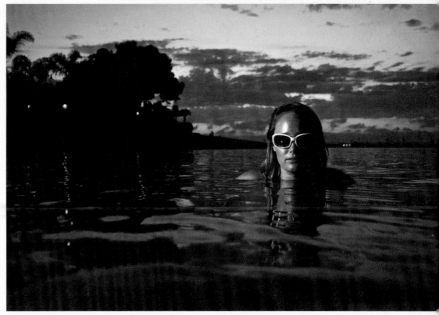

INDEX

Studio Lighting Unplugged

Rod and Robin Deutschmann show you how to use versatile, portable small flash to set up a studio and create high-quality studio lighting effects in *any* location. *$34.95 list, 7.5x10, 160p, 300 color images, index, order no. 1954.*

Painting with a Lens

Rod and Robin Deutschmann show you how to set your camera in manual mode and use techniques like "ripping," "punching," and the "flutter" to create painterly images. *$34.95 list, 8.5x11, 128p, 170 color images, order no. 1948.*

FLASH TECHNIQUES FOR
Macro and Close-up Photography

Rod and Robin Deutschmann teach you the skills you need to create beautifully lit images that transcend our daily vision of the world. *$34.95 list, 8.5x11, 128p, 300 color images, index, order no. 1938.*

Just One Flash

Rod and Robin Deutschmann show you how to get back to the basics and create striking photos with just one flash. *$34.95 list, 8.5x11, 128p, 180 color images, 30 diagrams, index, order no. 1929.*

Off-Camera Flash CREATIVE TECHNIQUES
FOR DIGITAL PHOTOGRAPHERS

Rod and Robin Deutschmann show you how to add off-camera flash to your repertoire and maximize your creativity. *$34.95 list, 8.5x11, 128p, 269 color images, 41 diagrams, index, order no. 1913.*

Multiple Flash Photography

Rod and Robin Deutschmann show you how to use two, three, and four off-camera flash units and modifiers to create artistic images. *$34.95 list, 8.5x11, 128p, 180 color images, 30 diagrams, index, order no. 1923.*

DOUG BOX'S
Available Light Photography

Popular photo-educator Doug Box shows you how to capture (and refine) the simple beauty of available light—indoors and out. *$34.95 list, 7.5x10, 160p, 240 color images, order no. 1964.*

THE BEST OF **Senior Portrait Photography,** SECOND EDITION

Rangefinder editor Bill Hurter takes you behind the scenes with top pros, revealing the techniques that make their images shine. *$34.95 list, 7.5x10, 160p, 200 color images, order no. 1966.*

Flash Techniques for Location Portraiture

Alyn Stafford takes flash on the road, showing you how to achieve big results with these small systems. *$34.95 list, 7.5x10, 160p, 220 color images, order no. 1963.*

LED Lighting: PROFESSIONAL TECHNIQUES
FOR DIGITAL PHOTOGRAPHERS

Kirk Tuck's comprehensive look at LED lighting reveals the ins-and-outs of the technology and shows how to put it to great use. *$34.95 list, 7.5x10, 160p, 380 color images, order no. 1958.*

Nikon® Speedlight® Handbook

Stephanie Zettl gets down and dirty with this dynamic lighting system, showing you how to maximize your results in the studio or on location. *$34.95 list, 7.5x10, 160p, 300 color images, order no. 1959.*

Step-by-Step Posing for Portrait Photography

Jeff Smith provides easy-to-digest, heavily illustrated posing lessons designed to speed learning and maximize success. *$34.95 list, 7.5x10, 160p, 300 color images, order no. 1960.*

Lighting Essentials: LIGHTING FOR
TEXTURE, CONTRAST, AND DIMENSION

Don Giannatti explores lighting to define shape, conceal or emphasize texture, and enhance the feeling of a third dimension. *$34.95 list, 7.5x10, 160p, 220 color images, order no. 1961.*

BILL HURTER'S
Small Flash Photography

Learn to select and place small flash units, choose proper flash settings and communication, and more. *$34.95 list, 8.5x11, 128p, 180 color photos and diagrams, index, order no. 1936.*

Studio Lighting Anywhere

Joe Farace teaches you how to overcome lighting challenges and ensure beautiful results on location and in small spaces. *$34.95 list, 8.5x11, 128p, 200 color photos and diagrams, index, order no. 1940.*

Family Photography

Christie Mumm shows you how to build a business based on client relationships and capture life-cycle milestones, from births, to senior portraits, to weddings. *$34.95 list, 8.5x11, 128p, 220 color images, index, order no. 1941.*

Flash and Ambient Lighting
FOR DIGITAL WEDDING PHOTOGRAPHY

Mark Chen shows you how to master the use of flash and ambient lighting for outstanding wedding images. *$34.95 list, 8.5x11, 128p, 200 color photos and diagrams, index, order no. 1942.*

Master's Guide to Off-Camera Flash

Barry Staver presents basic principles of good lighting and shows you how to apply them with flash, both on and off the camera. $34.95 list, 7.5x10, 160p, 190 color images, index, order no. 1950.

On-Camera Flash TECHNIQUES FOR
DIGITAL WEDDING AND PORTRAIT PHOTOGRAPHY

Neil van Niekerk teaches you how to use on-camera flash to create flattering portrait lighting anywhere. *$34.95 list, 8.5x11, 128p, 190 color images, index, order no. 1888.*

Off-Camera Flash
TECHNIQUES FOR DIGITAL PHOTOGRAPHERS

Neil van Niekerk shows you how to set your camera, choose the right settings, and position your flash for exceptional results. *$34.95 list, 8.5x11, 128p, 235 color images, index, order no. 1935.*

THE DIGITAL PHOTOGRAPHER'S GUIDE TO
Natural-Light Family Portraits

Jennifer George teaches you how to use natural light and meaningful locations to create cherished portraits and bigger sales. *$34.95 list, 8.5x11, 128p, 180 color images, index, order no. 1937.*

WES KRONINGER'S
Lighting Design Techniques
FOR DIGITAL PHOTOGRAPHERS

Create setups that blur the lines between fashion, editorial, and classic portraits. *$34.95 list, 8.5x11, 128p, 80 color images, 60 diagrams, index, order no. 1930.*

DOUG BOX'S
Flash Photography

Doug Box helps you master the use of flash to create perfect portrait, wedding, and event shots anywhere. *$34.95 list, 8.5x11, 128p, 345 color images, index, order no. 1931.*

Advanced Underwater Photography

Larry Gates shows you how to take your underwater photography to the next level and care for your equipment. *$34.95 list, 8.5x11, 128p, 225 color images, index, order no. 1951.*

Boutique Baby Photography

Mimika Cooney shows you how to create the ultimate portrait experience—from start to finish—for your higher-end baby and maternity portrait clients. *$34.95 list, 7.5x10, 160p, 200 color images, index, order no. 1952.*

Lighting Essentials

Don Giannatti's subject-centric approach to lighting will teach you how to make confident lighting choices and flawlessly execute images that match your creative vision. *$34.95 list, 8.5x11, 128p, 240 color images, index, order no. 1947.*